THE AIB PRIZE

An Annual Award for Artists of Promise

Paul Doran is the recipient of the AIB Art Prize for 2005. The prize, an annual award which identifies a promising Irish visual artist, is dedicated to financially assisting the production of a significant solo exhibition and relevant publication at this pivotal point in the young artist's career.

Profile 24 – PAUL DORAN

Published as part of Gandon Editions' PROFILES series on Irish artists (details, page 82).

ISBN 0948037 30X

(Also published in a special clothbound edition as PAUL DORAN – MAN IN A SHED, ISBN 0948037 334)

© Gandon Editions and the artist, 2006.
All rights reserved.

Editor John O'Regan

Asst Editor Nicola Dearey
Design John O'Regan
 (© Gandon Editions, 2006)
Production Nicola Dearey
 Gunther Berkus
Photography John Kellett
 David Cantwell
 Paul Doran
Printing Nicholson & Bass, Belfast

Distributed by Gandon and its overseas agents

contents

Publication and exhibition grant-aided by AIB

THE AIB PRIZE
An Annual Award for Artists of Promise

GANDON EDITIONS
Oysterhaven, Kinsale, Co Cork, Ireland

tel +353 (0)21-4770830
fax +353 (0)21-4770755
e-mail gandon@eircom.net
web-site www.gandon-editions.com

cover Untitled, 2005

Gandon Editions is grant-aided by
The Arts Council /
An Chomhairle Ealaíon

Published to coincide with the exhibition
Paul Doran – Man in a shed at

SLIGO ART GALLERY
Yeats Memorial Building, Hyde Bridge, Sligo
(28 March – 29 April 2006)

tel +353 (0)71-9145847
fax +353 (0)71-9147426
e-mail sagal@iol.ie
web-site www.sligoartgallery.com

ACKNOWLEDGEMENTS

The artist would like to thank the following:

AIB Group for their very generous support through this award; the panel of selectors: Aidan Dunne, Margo Dolan, Antonia Payne and Dr Frances Ruane; art administrator Maureen Porteous.

Robbie McDonald, Áine O'Gara and Louise Curran at Sligo Art Gallery; authors Robbie O'Halloran, Sally O'Reilly, Mark Swords; publisher John O'Regan of Gandon Editions; photographers John Kellett, David Cantwell and Mike O'Toole.

Jerome O Drisceoil, Molly Sullivan, Karen Tierney at Green On Red Gallery (especially Molly Sullivan for editing the texts).

The Doran family.

The Green On Red Gallery expresses its gratitude to all the collectors and institutions who have generously supported Paul's work over recent years.

Profile **Paul Doran**

GANDON EDITIONS

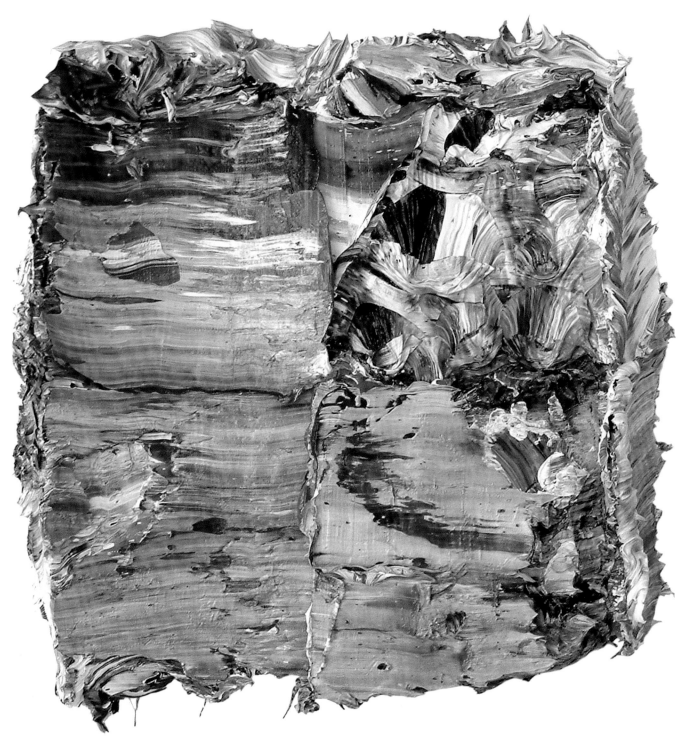

Foreword

Since its foundation in 1977, Sligo Art Gallery has been pivotal in the development of visual art practice and education in the north-west. The objectives of the gallery are to sponsor and encourage all artistic endeavour within the community and to provide a space for the exhibition of contemporary art. Founded at a time when few such facilities existed in Ireland, the gallery set out to support and develop visual art practice in Sligo town and beyond. In the thirty years since then, it has pursued and nurtured a programme of exhibition and events which has brought a series of important and excellent work to the people of the north-west. Sligo Art Gallery is funded by The Arts Council / An Chomhairle Ealaíon, FÁS and the Friends of the Gallery.

Sligo Art Gallery is very pleased to have nominated Paul Doran for the AIB Art Prize in 2005. A consummate painter, Paul Doran's practice has cut to the edge again and again, pushing at possibilities, seeking new answers. Although artist and gallery are located at diagonally opposite corners of the country, we recognised in him a painter of steely integrity and dedication, who would best utilise the opportunities such a prestigious prize would give him. We offer him our sincere congratulations, and look forward to witnessing the further development of his most promising career.

This book is published to coincide with an exhibition of new work by the artist at Sligo Art Gallery, *Paul Doran – Man in a shed*.

Can't take my eyes off you
2003, oil on linen over board, 30.5 x 30.5 cm

Sligo Art Gallery, Yeats Memorial Building, Hyde Bridge, Sligo
tel +353-(0)71-9145847 / fax + 353-(0)71-9147426
e-mail sagal@iol.ie / www.sligoartgallery.com
director: Robbie McDonald / administrator Louise Curran

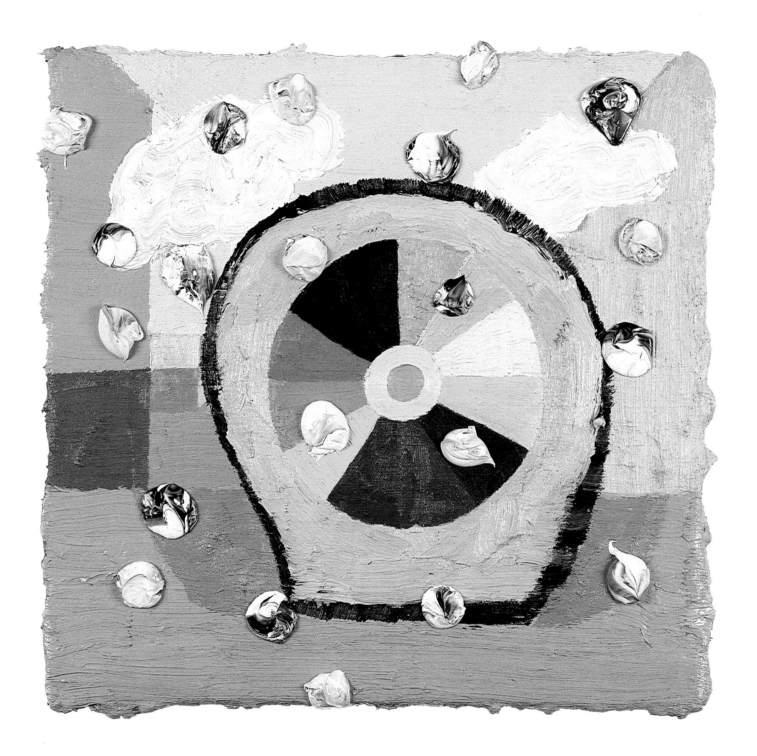

Critical Mass

ROBBIE O'HALLORAN

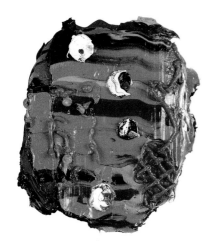

Leave it alone
2001-03, oil, 30 x 25 cm

Untitled
2006, oil on linen over board, 40 x 42 cm

THE ISSUES ASSOCIATED WITH SURFACE IN PAINTING ARE NOT NEW, AND THE QUESTION OF HOW TO deal with the surface is still central to a great number of artists' practices. In the mid-1990s, art college painting departments were in thrall to what was being loosely called 'process' painting. This type of work generally rests on a single well-crafted conceit. The gesture is emphasised and often mediated by a more limiting means of application than a paintbrush. The application of paint to a surface in a single considered movement necessarily reduces control, and focuses attention on 'getting the gesture right'. It also has the interesting effect of limiting the scale of the work to that area which can comfortably be covered in one movement.

In retrospect, 'process' seems a crude term, as all painting surely requires process, but what was impressive about this work was its effective simplicity and the apparent self-confidence with which it abandoned itself to the medium. It seemed, to take Greenberg's Modernist conviction, that art could function '...in the use of characteristic methods of a discipline to criticise the discipline itself, not in order to subvert it but in order to entrench it more firmly in its area of competence'[1] to a liberating new level. So-called 'process' painting, by foregrounding the physicality of the paint and exposing the evidence of its own production, seemed to be defying

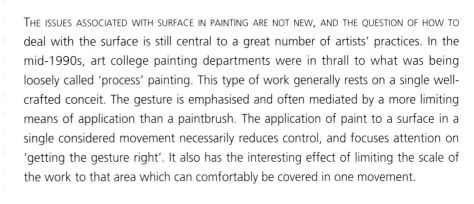

Leabharlanna Poibli Chathair Bhaile Átha Cliath
Dublin City Public Libraries

a prevailing sense of embattlement. This sense of embattlement was felt by artists who were being told from all corners that painting was on the way out. This crisis of confidence resulted in a hyper-critical, even defensive stance. Process painting was a type of work which flaunted its materiality, and at the same time, through the rigours of methodical, almost mechanical process, pointed to a possible way to work through the debate. It appeared that the freedom to produce work had been won. Painting had bought itself some time.

Paul Doran's earlier work began to emerge from this process-bound approach. The signature 'dragging' technique, by which he pulled and pushed impossibly thick skeins of paint across the support, was worked through successive stages of development, each one verging on a new level of excess. Each new layer consumed the last, sometimes dragging the previous one with it to the edge in a violent streak. The edges blistered. In places, the hint of a vivid pastel underlayer could be made out under deadpan greys, browns and near-blacks. What may have been signs of a lighter, even a more light-hearted painting underneath were now only visible at the edges.

The excesses of Doran's earlier 'process' painting (and I use this term with an already assumed acceptance of its redundancy) – piling the paint onto the canvas to such an extent that it becomes subsumed – points to a couple of things: firstly to an escape, an escape from the intimidating finality of the support itself. All painters are, in essence, working backwards from an already finished object. The blank canvas can seem to pulse with a vivid completion. Then there is the burden of paint, the sheer physicality of the overloaded support, in places no longer visible, which can be seen as an overloading in every sense. The paint seems to be pointing to the inadequacy of the canvas to support it. It has, in a way, become too big for its boots.

One of the striking things about this earlier work is its consistency of approach to the surface. It is a simple device, but an effective one. The consistency of method achieved, it was now possible to develop it in a spirit unburdened by over-examination. There would be no more second-guessing. In works such as *Leave it alone* (2001-03), the surface has developed some

interesting additions. A series of cross-hatched marks, like a fragment of drift-netting, has settled and become entangled in one corner of the painting. It is the hint of a grid – loosely drawn and straight from the tube, perhaps. It is cartoon excess. In these paintings the basic formula remains the same, but now the surface admits other elements. In this stage of their development, marks and gestures become grafted and superimposed onto the main body of the paintings. In places, the skin of the outer layers is removed and pulled aside to reveal the sub-layers. The immediacy of the surface has become disrupted.

The notion of immediacy with regard to the surface of a painting points directly to Clement Greenberg and the Abstract Expressionists. Greenberg identified the Modernist approach to surface as a defining aspect of its identity. Taking Cubism as a starting point, he began to imagine a surface which, through its matter-of-fact materiality, necessitated a shift in the interpretive response – that is to say, a shift in how we read the surface. The fractured space of Cubism – through, first, dispersal, then rearrangement – attempted to encompass all perspectives at once. This dispersal of all spatial elements, so that they came to be read almost simultaneously, ultimately fed into Greenberg's development of an idea of immediacy with regard to the surface of abstract expressionist painting. This kind of painting, Greenberg considered, was less mediated, more spontaneous than cubism, and therefore more immediate. The heightened materiality of the surface in much Abstract Expressionist work would no longer require the viewer to read the painting in the sense of examining it for information. It would no longer be read in a narrative manner. This is perhaps best exemplified in the 'all-over' surface of later Pollock – analogous to simultaneity of image and reception.

Greenberg's idea comes unstuck, however, if we attempt to apply it to more recent process-dominated painting. Even at the time of their development, his ideas for a coherent and neat evaluation of surface would unravel in the context of certain artists' work. Hans Hofmann's work was problematic for Greenberg, coming as it did from an immersion in the European traditions, and yet displaying an understanding of Abstract Expressionism. For Greenberg, Hofmann's paintings displayed a

'distractedness'[2] which seemed to come from the uneasy meeting of what was considered to be an Abstract Expressionist surface with other elements, other gestures and other perspectives which corrupted it.

The Modernist impulse was towards unified systems and large, self-reflexive projects. The work of painting resists the imposition of grand designs. It is hard to position 'process'-driven work within a more complex dialogue due to its stubborn tendency to limit itself to the level of technique. The work is opaque and instantaneous, and our gaze bounces away from the surface. Andrew Benjamin has suggested that

> ...artworks have a greater complexity than that which is given in the simultaneity of giving and receiving ... the presence of this complexity underscores the fact that the only possibility for immediacy is its occurring as a secondary effect of a more complex set up. Immediacy occurs after the event.[3]

So, it must be said that Doran's paintings, whilst appearing in the early stages to rest on the rigours of process, were never exclusively about process. The systematic development of the surface to such levels of excess now becomes a starting point for something else. The depth of the most recent paintings in the exhibition *Gislebertus told me* rests more on the use of illusionistic devices than it does on the application of paint in hyper-relief. The paint is still textured and impasto. The surfaces, however, now admit more controlled incident. The geometric interiors and perspectives of the Sienese school, and the vivid palette of artists such as Sassetta, now inform the surface. For these artists the realistic rendering of architectural perspective, within which the devotional dramas are acted out, is as important a formal element as the story itself. The methodical formalism of the rendering, combined with the light greys, ochre and pinks of the tempera panels, lends these dramas a certain austere calm.

As with the Sienese painters, formalist concerns also serve as a vehicle for pictorial complexity in the carved relief of the Romanesque sculptor Gislebertus. Relief sculpture is an essentially pictorial form. Operating as it does in two dimensions, it points to the pictorial problems of surface depth, both real and implied. In a way, it could be conceived of as being one of the most formal pictorial modes. Using simply the manipulation of material – in this case, stone – to articulate a pictorial space, it might also be seen as one of the purest 'process'-driven artforms.

The marks and gestures which began to accumulate on the surfaces of Doran's earlier paintings, and which not just embellished but complicated those surfaces, are carried through in the latest works also. This time, however, it is of a much more controlled and sophisticated order. Organic blotches, seeping paint from underneath their edges, lie ominously on the surface, in relief, like a fungus, threatening to take over the entire painting. There are other, more geometric elements which appear on the surfaces also, as though cut and pasted from other works. They are spliced and literally grafted, in areas crossing over and under each other. The intricacy of these elements, in sometimes awkward juxtaposition, resists the matter-of-fact reading afforded to artwork which rests on the evidence of the medium alone. The space of these paintings is difficult and multi-layered. Opaque physicality, in the form of superimposed marks, is set in relief against flat perspective devices which only appear to recede into the surface of the painting. These works, informed as they are by both the historical and the contemporary, attest to the complexity of the painted surface and to our inability to provide it with any totalising response.

Robbie O'Halloran was born in Waterford in 1975. He has exhibited regularly since completing his masters in painting at the National College of Art & Design, Dublin, in 2001.

ENDNOTES

1 Clement Greenberg, 'Modernist Painting' (1960) in John O'Brien (ed.), *The Collected Essays and Criticism, vol. 4: Modernism with a Vengeance, 1957-1969* (University of Chicago Press, 1993) p.85
2 ibid., p.192
3 Andrew Benjamin, *What is Abstraction?* (Academy Editions, London, 1996) p.27

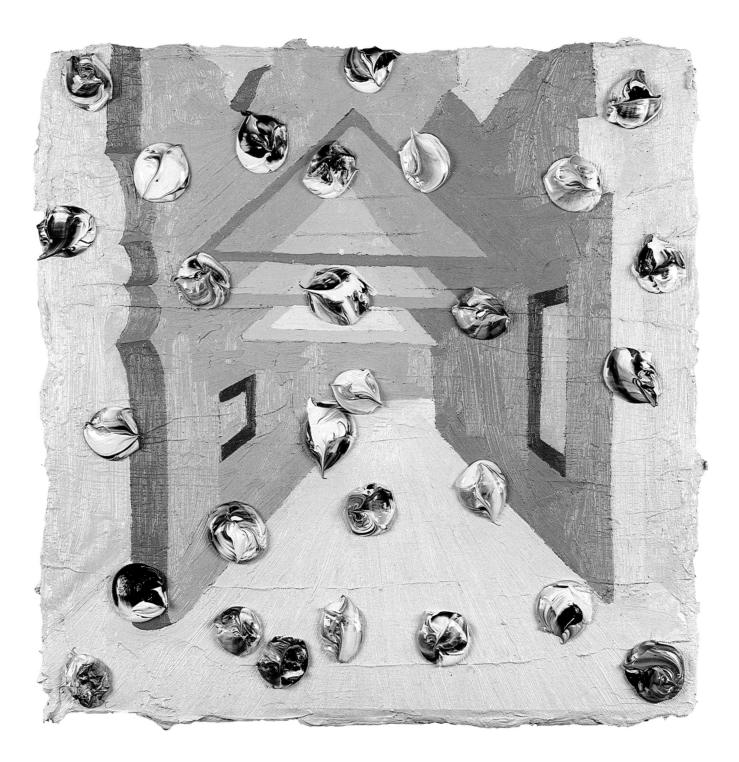

Circling the
Square

SALLY O'REILLY

THERE ARE PAINTINGS THAT COME OUT TO GREET THE VIEWER, LEAD THEM THROUGH OPEN VISTAS OF meaning and down blind alleys of ambiguity among channels of logic. There are others that retreat into murky regions of doubt and contradiction, leaving the viewer stranded outside, complacent. Paul Doran's latest canvases suggest spaces that entice us in, but instead of chambers of sense and integrity, they are structured from prismatic uncertainties.

Doran's modes of construction of these spaces are various. Regions painted in closely related colours tessellate, abutting as if supporting one another; or girders of one pigment are dragged or slathered over an underlying impasto in another in order, under the jurisdiction of perspective, to portray illusory interiors. Doran has employed a new set of laws to be obeyed, switching focus from the pull of gravity and push of accumulation of his previous work – in which he piled up paint into lustrous encrusted carapaces – to the alchemy of perspective, and diplomacy of support and interruption. At times, pictorial elements seem to be unsure whether they are interdependent or at odds, collaborative or combative. The dialogue between line and texture, colour and form sometimes escalates to an argumentative pitch. The suggested space oscillates between unfeasible and idealised, just as

Untitled
2006, oil on linen over board, 46.5 x 46 cm

a quarrel wavers between logical and ludicrous. Often the impasto of their underpainting sets the whole surface in motion along another axis, like a squabble on rollerskates on a boat. Sometimes a shape has been cut from a thick dried layer of paint and stuck on top of the denoted space, like an interjection or a dogmatic insistence.

It is perhaps no surprise that I use analogies of speech and language in relation to these paintings. Doran's previous, entirely abstract paintings are like guttural utterances, while these are more like descriptive sentences, albeit somewhat vague. Where earlier canvases were smaller, more thickly smothered with pigment and more liable to be soaked up as haptic phenomena than read as illusory images, here they speak a defective but recognisable language of representation. Among the logical constructions there are malaprops and mixed metaphors, forms slur and layers talk over one another, but we are nonetheless presented with snippets of the lingua franca of objects in space.

In fact, all representational imagery operates like language, referencing something elsewhere, expressing the idea of an absent object, place or person through a visual proposition, which the viewer interprets with recourse to his or her own optical experience. It is a complicated mechanism of deferral, removal and reassignment. But why might representational images start appearing in the work of a painter who has previously avoided them? Perhaps the impulse to represent objects, places or peo-

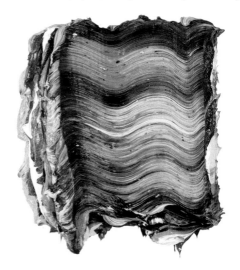

Messiah
2002, oil on linen over board, 23 x 23 cm

ple had been previously repressed, like some animal urge, or maybe the work has undergone a sudden gentrification, a switch from primordial immediacy to drawing-room allusions.

Doran has not suddenly started painting trees or portraits, but notional spaces. This is not a diversion along a narrative or necessarily figurative course; rather, Doran sustains similar formal preoccupations. His earlier orgies of pigment existed in the same register as the viewer in the gallery. Great dollops and smears of paint oozed from the edges of the canvas and were piled up on its stretched expanse, which, like fingerprints on a window, drew all attention away from any perceivable image beyond it. This has, historically, been the strategy of abstract painting – to refute the canvas as a portal and establish it as an object with its own autonomous presence and validity. Although an apparent U-turn on these issues, these newer paintings do not wholly surrender themselves to the task of picturing. They wear their own construction on their sleeve, and refer not to realities elsewhere, but irrealities that can only exist as paint. In a sense, through its lackadaisical descriptive tone, the paintings retain aspects of abstraction's indifference to the world as it appears elsewhere. This hermetic characteristic of abstraction has, at certain points in art history, been considered utopian or naïve or arrogant; or, conversely, it has been characterised as emancipated or pure or egalitarian – free from the slavish relationship that reminds us of our hide-bound restrictions. Whereas a photograph fixes a particular tree, a poem suggests to each reader a different, private tree. Certainty is replaced by doubt, and doubt is a creative state compared to dogma.

To continue the linguistic analogy, poetry involves the use of words not only as references or pointers to something elsewhere, but also as a painterly medium to be arranged with sensitivity to texture, tone, warmth, angularity, tempo, and so on. Someone once explained poetry to me as a stained-glass window: the light shines through so that the translucency of the material is activated, flooding the space with coloured light while also illuminating a figurative scene. This is the interface between atmospherics and representation towards which Doran has now edged his work.

Surprisingly, perhaps, like poetry, the mathematic language of geometry is at once dogmatically positivist and malleably abstract. It comprises a vocabulary of symbols with multiple applications and associations. Metaphorically, the circle and square embody eternity and stability, yet we can also reassign them as boundaries of distinct places in plans and maps. We have an innate ability to switch between analogy and reality when map-reading, to project a generic form into a specific surrounding – the boundary of a house onto a hillside, for instance. We can mentally orientate ourselves in a space that we have never been in through such projection and imagination. In fact, you can only imagine things that aren't there. Sometimes a thing's absence is the only way to recall it; literally nothing, no thing, is a constructive proposition.

In geometry and the physical world, space comprises not nothing, but the intervals between points or objects. Space is between things, place is where things are. Place is space with fixed reference points. Cognitive psychology recognises the mechanism of coding an object's location as relying on landmarks. A landmark should ideally be unlikely to move and perceptually salient, familiar, and/or a functionally important entity. We give directions with reference to pubs or train stations or churches; we say the keys are on the coffee table or by the door. Identifying Doran's paintings necessitates a similar process of cross-referencing. As all works are untitled, we describe them through particular combinations of their familial chromatic themes (greys and beiges, oranges and pinks) and permutation of forms (chambers and boxes, black goo and eggy blobs). We might say, 'the one with the hollow pink box in a beige corner', or 'the eggy blob behind bars', or 'the pink chequerboard'. The differences and similarities between elements are as important as the unity of each whole.

Indeed, the eye and brain are more perceptive to diversions from regularity than complete randomness. We spot the recurrence of motifs in these paintings, and then their differences. Dürer's use of the grid to formulate perspective exploits this propensity: perspective involves the persuasion of the brain that it perceives a reality, but the brain has to want to do so. In *Art and Illusion*, Gombrich explains how there is such a thing as the

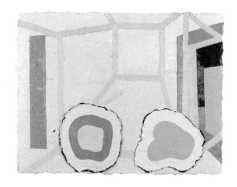

Untitled
2005, oil on linen over
board, 75 x 100 cm

correct rendering of perspective, although this may stand in for an infinity of shapes in space. We bring our experience and expectations to an image to decide how it is interpreted, so in a way the image demands our collaboration. This is the basis of the gestalt effect – the process by which a figure-ground relationship is prioritised over another – which has found applications in fields as far-flung as military camouflage and optical parlour games.

Doran tumbles illusory spaces within one another, conflicting all manner of priorities and undermining logic. Although certain pictorial elements – his pink chequerboard floor, for instance – may propose solidity, his hollow boxes pop in and out of their possible concave and convex configurations. If we concentrate on one painting, our eye almost gives up trying to logically relate the central hollow form to the solid space that seems to house it. Two walls recede from us on the left and right, barring the way for the airier, more elastic box form that threatens to expand between them, so that it is forced to snap forward, to reassert the surface of the picture. But it is not even allowed to reside here, as this non-illusory space – the surface of the painting – is reserved for the two eggy shapes that have been pasted on to it. The composition is restless, the pink box in limbo, passed from pillar to post by contradictory reference points in multiple planes.

———

Doran identifies Sienese painting as one of the predominant historical markers for his practice. The period generally considered

important in the city of Siena is the late 13th century to the late 15th century, after which canonical attention turns to Florence and the Renaissance. Artists such as Simone Martini, Duccio, Ambrogio and Pietro Lorenzetti, Sassetta and Francesco di Giorgio shared, besides religious subject matter, an interest in architectural structures, innovative and imaginative representations of space, and a chromatic sensibility that all reflect the qualities of Siena, its architecture and surrounding landscape. The colours and rhythms of their paintings are complex and musical. Made before the formulation of perspective during the Renaissance, there are vestiges of Euclidean space, although their compositions still retain vertiginous mediaeval anomalies. Foreground and background, landscape and interior often interpenetrate; interiors, caves and views through arched windows create rhythms echoed in the choreography of the human figures within them. Often architecture provides not only a convening space for saints, Christ and the hosts of heaven, but also a structure that spans the frontal plane of the picture itself, like compositional scaffolding. This duality of support – of the real space of the canvas and the represented space of the scene – could be thought of as a precursor to abstract painting's bricking up of the window, the insistence on its own presence rather than the absence of what it depicts.

Doran galvanises this transition when he isolates the structure of a vaulted roof, and paints it in cheerful pinks and oranges. The joists and rafters are described in raw colour, devoid of tonal rendering, as if bars of paint could constitute architecture. The character of the paint is paramount, its movement and textures rendering the symmetry and constancy required of architecture entirely secondary. This roof would never survive in the world of gravity and winds, but here, in Doran's idealised worlds, it pulses and rhymes with a different sort of tenability.

Once Doran's connection to Sienese painting is noted, compositional motifs adopt new significance. The curious fried-egg shapes, for instance, which have somehow arrived within or are stuck onto the front of these spaces, recall Giovanni di Paolo's world map inserted into the landscape of The Creation and The Expulsion (1445). The earthly domain, denoted by mountains and rivers and plains, is insulated by concentric circles – an echo

of Dante's 'lofty wheels' – so that the secular punctures the heavenly realm of Eden. The sacred and the profane are brought into association, yet are represented in divergent scales, implying that they could never truly convene. Using a similar ploy, Doran's work pitches a pink linear cube into contradiction with the horizontals and verticals of the grey space described around it, and then introduces a blob that hovers on the threshold like a reticent guest. Doran leaves evidence of the thick black paint that holds this apparition in place, seeping around the edge like ectoplasm from another world.

This apparition reminded me of the novella Flatlands, by Edwin A Abbot (1884), written before the widespread formulation of multidimensional mathematics and a prophetic parable on such a possibility. The central character, A Square, is an inhabitant of a two-dimensional world. He is visited by a sphere, which manifests itself as a circle that dilates and then retracts; essentially, A Square witnesses the cross-section of a sphere as it passes through his fixed horizontal plane of perception. When he recounts the visitation to his neighbours, he is vilified as a heretic, representing a dangerous breach to the hermetic two-dimensionality of Flatlands. Abbot's insinuation is that, in a positivist world of two dimensions, solid form is imperceptible, and therefore perceived as supernatural. In our Einsteinian universe we have accepted multiple and malleable dimensions, and yet there is still an appreciation of metaphysical phenomena that is beyond physics or nature, or somehow otherwise unverifiable by logical positivism. The religious metaphysics of Sienese painting in the fifteenth century, then, has its counterpart today in the continued sighting of apparitions, extraterrestrials, and the formulation of geometric systems that we can barely imagine.

If we look at the work of the most influential metaphysical painter of the last century, Giorgio de Chirico, we find strange interlopers reminiscent of Doran's eggy blobs: corporeal suns have strayed into the logical framework of architecture, appearing in rooms or on a beach, replicated either side of a horizon. Throughout De Chirico's paintings, familiar objects are uprooted from their habitual contexts to assume symbolic import. They are arranged in odd worlds without rules, in non-specific places like shorelines, piazzas, valleys and generic architectural

enclosures, in enigmatic, melancholic or prophetic still lifes. De Chirico's orchestration of a tension between the real and the metaphysical finds an equivalence in Doran's infection of geometry with biology, the optic with the haptic, and the static with the moving. De Chirico's intention was to formulate a metaphysical version of mnemonic systems – memory aids that rely on association and substitution – which served to retrieve the past and its images. Memory and perception, mimesis and reality, like the present and the past, will always be at one remove from one another, but are associative.

Doran's geometry, so frail and flawed, is like a badly remembered event or place, pieced together from different perspectives that don't quite match up to a solid account; his bridges to the real and the past are very rickety. His spaces, like De Chirico's temples, beach huts and puppet theatres, are emptied of humans. They are portentous, preternatural even. They suggest potential rather than the past, something about to occur, a memory about to be formed. The act of remembering and the act of theatre seem associated, as they both strive to create something from nothing. As Peter Brook wrote in *The Empty Space* (1968), 'I can take any empty space and call it a bare stage. A man walks across this empty space whilst someone else is watching him, and this is all that is needed for an act of theatre to be engaged.' The relationship between painting and theatre has remained relatively unexplored, though, aside, that is, from Michael Fried's insistence in *Art and Objecthood* (1967) that what 'theatre addresses is a sense of temporality, of both time passing and to come, simultaneously approaching and receding as if apprehended in an infinite perspective...', and consequently, as painting is experienced instantaneously, it can never be theatrical. But painterly space and time have been irrevocably fragmented and set in motion by Cubism, Futurism, Surrealism and Abstract Expressionism, reaching a nihilistic apotheosis with the monochrome – the blip of disappearance of time and space in painting altogether. We are all, by now, pretty fed-up of hearing about the death of painting, the death of art in general, of authorship (Roland Barthes), of reality (Jean Baudrillard) and even of history (Francis Fukyama). What may be more productive is to consider a distinction drawn by Yves Alain Bois in the essay 'Painting: The Task of Mourning' (1986). He marks a dissociation between a generic game (for instance, chess) and a specific performance (a particular chess game between two individuals), which he calls play. A painting, then, rather than presenting a progression through a series of bouts of a fixed game, can instead return to the base rules of the game, constituting not a development, but a new departure.

The differentiation between painting as play or game resurrects the medium and makes it immortal, but it also offers us a neat bridge back to the dual function of geometry. The space of play is unbounded, or as constricted as the imagination of its players. Games, on the other hand, have rules and quite often occur within the bounded space of a board or a court or a box – games are architectural at base. Doran's paintings, then, could allude to all sorts of games – the collaborative game of perspective, the chequerboard of chess, the empty chambers of de Chirico's mnemonic riddles. But then, there are those eggy blobs that defy description. They are of a different language, accent, intonation and colloquy from any of these games. After scouring my vocabulary to find words to match their enigmatic presence, I finally buckled and asked Doran how I might refer to them. He talked of them in relation to Philip Guston – another painter who notoriously made the transition from wholly abstract work to figuration – and his attempts to find a form to which everything could be reduced, a pictorial device that would signify the contemporary in its entirety. Doran's answer to this is these indistinct, quasi-geometrical lumps – the embodiment of ambiguity. As he puts it: 'They appear to be something, at the same time they reveal themselves as nothing.' If you really can only imagine something in its absence, then these intense concentrations can only have found a home in the purgatory of semi-abstraction, where the possibility of the unthinkable, that which is beyond language, can be somehow articulated.

Sally O'Reilly is a freelance writer and critic, contributing regularly to numerous UK-based magazines. Also co-editor of *Implicasphere*.

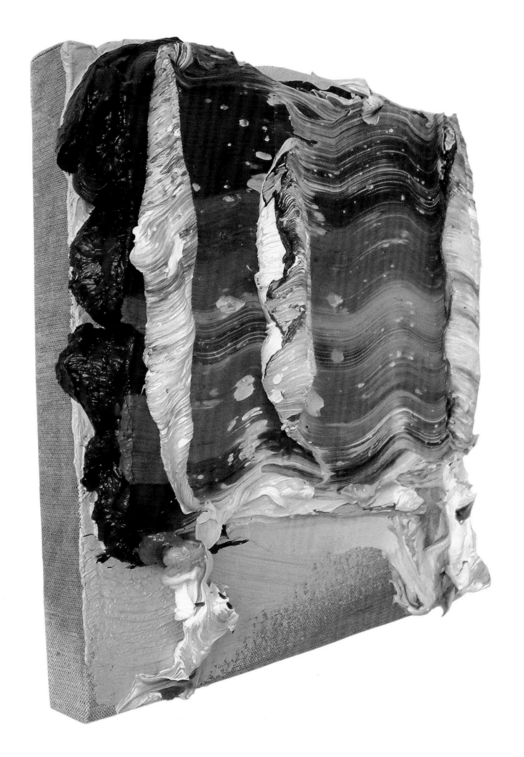

A Conversation with the Artist

MARK SWORDS

MARK SWORDS AND PAUL DORAN ARE BOTH PRIMARILY PAINTERS. THEY HAVE KNOWN EACH OTHER since 2000 and have discussed each other's work extensively. Doran's Masters degree exhibition in 2001 marked a definite shift in his career. The work from this time onwards is the basis for this conversation.

Mark Swords – Having taught art in secondary school for a few years, are you aware of art history in a way that a lot of contemporary painters aren't?

Paul Doran – Yes, I suppose, but I've always been very aware of art history. Even as an undergraduate I spent as much time in the library as in the studio. When I became a secondary school teacher I had to clarify in my own head that whole concept of a linear progression of art history. That was quite interesting because the art history course in secondary school begins in the late 10th / early 11th century with the Romanesque period, and at a time when the dominant visual art forms were architecture and sculpture. Painting didn't come on stream at all until the late 12th century.

Preparing a lesson every day must have almost forced an awareness of art history.

Delicate
2004, oil on linen over board, 30.5 x 30.5 cm

Yes, it did. But Another factor was that in my degree year and during the MA, all the seminars and discussions were about contemporary artists. I often found that a little uninteresting. I didn't think it was the best way to inform my practise or to help me to think about it. At times, it was actually a hindrance. On the MA course, people were operating within an atmosphere that was ultra contemporary. It was all very *Vitamin P* in regards to a dictionary of painters, whereas I found myself looking in the library at really old history books at Renaissance and pre-Renaissance.

Your passion and level of interest in art history didn't visually manifest itself in your work at the time.

It did in regard to scale. With the Vermeers or any of the old icon paintings I had seen, I was always initially gobsmacked that they were so small, and yet had this incredible intensity and could be so commanding at that scale. A lot of contemporary painting now is quite small, but at the time I was doing my Masters it seemed that everyone was working larger. The prevailing attitude in colleges, particularly in NCAD, was 'I'm going to make a big painting', and I'm not sure how much reasoning went on there other than the desire to create as big as could fit in a studio. I made the decision then to destroy a lot of work, and I decided to go with six tiny paintings for my MA show. I wanted to create an intensity and a quality that exists in some of the old paintings – not stylistically but in terms of vigour.

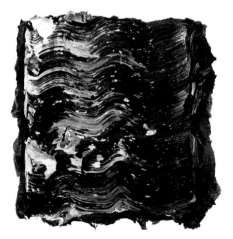

Cracker
2001, oil on canvas over board, 30.5 x 30.5 cm

Your smaller paintings were no less ambitious given their scale. They weren't small in the sense that some of those icon paintings can be. Many panel paintings were part of much larger assemblages that built up to become something more physical, more dominant objects of power. The notion of ambition in terms of scale can become confused when we are not seeing historical work in the right setting. We could be looking at little Fra Angelicos that were designed as part of a twenty-foot altarpiece, but we might only be seeing a fragment of them. The other thing in terms of ambition with the small MA paintings is that they were very heavy, physical objects. They were ambitious in terms of how far you pushed that physicality. Is that the only way your interest in art history manifested itself at that time?

It was mostly about scale. I think it's quite remarkable that even today some of those old icon paintings in museums can still actually command attention. That focus was something that was really important to those six paintings in my MA show. They were illustrative of my search for intensity, my attempt to grab someone's attention, to stand for a few minutes with these paintings.

Having recently seen Fra Angelico and Van Eyck panels, they impressed me in a quiet way. They had an otherworldly or spiritual quality. I found myself thinking about the amount of time, energy and dedication tied up in them. They were incredibly skilful and never apologetic about that skill.

Yes. They were, by and large, made by monks – the hand of God. That's something I've been thinking about for a long time – it's nice to hear someone else say it!

I'm just trying to point out an irony. A criticism that might be levelled at earlier works of yours is that they were just a bit too much about showing off in terms of technical ability. But, in fact, that's something they share with icon paintings. The ideas of skill and precision have very different connotations in contemporary painting. The MA show marked an important stage for you, and possibly a new approach to your practice. Did your lifestyle and/or relationship with the studio change at that time?

I think the intensity of how I actually work changed. I cut out things from my life at that time, things that I was involved in and doing. So yeah, certainly the amount of time I spent in the studio and the concentration with which I pursued what I was doing changed completely. When I was making the earlier work, there was, I suppose, a certain amount of me realising that I always had the ability to achieve a painting, that I could gladly pursue and pursue and achieve it, and that was the end of it. But, although I worked very hard in the studio, there wasn't the same depth of focus, level of concentration or engagement with the work that there is now.

Before the MA you were very interested in the work of Howard Hodgkin, and that almost acted as a cul-de-sac for your work.

In hindsight I think I was too naïve to realise that my interest in Hodgkin was not necessarily in the physicality or the 'look' of his paintings. I was more interested in what I had read about Hodgkin. I remember reading interviews and feeling a connection with how he would talk about emotion and memory in painting, and how you could, in some way, deal with that through paint and colour. That was really what I was interested in about Hodgkin, and how I connected with him.

Maybe there's a naïvety or a difficulty in knowing how to deal with the realisation that one has a genuine connection with another artist. So, instead of the 'look' of a Hodgkin, you're talking about connecting with the intent behind the work. But Hodgkin could be held up as an example of someone who can make a small painting with a huge visual impact. There are all sorts of things we've touched on already that seem like obvious reasons for you to be interested in Hodgkin, but maybe you were able to process that influence better and it stopped having any kind of strong impact on your own work. Did you find yourself in a position that was more genuinely yours?

Yes, you spend so long searching for something of your own and trying to work things out. Then, you start to find a way of working that you get quite excited about, where you don't necessarily think of other people immediately. That's quite an exciting point to arrive at.

There's an aspect of that idea that I think we're both very critical of now – this notion of having a 'thing' and just going with it. That's fine, as long as you're willing to realise that change occuring within a practice is healthy. I remember when we first met we talked about that idea without any afterthought. That notion of change and challenging your own work wasn't important to us. One of the things we talked about was finding your own space, finding your niche. You do find a way of painting that is not too desperately associated with other people. All sorts of associations were made between your earlier work and lots of other painters, which bugged you.

I think they were lazy associations. I think if you take those six paintings that were made in 2001, and put them in a room with the people who I was being compared to – people like Jason Martin and Zebedee Jones particularly – there is no mistaking that they were my paintings. I think if people really knew Zebedee Jones and Jason Martin's work, they would realise how they were just operating in a different space, had a different agenda. They may have had similarities, but so did the whole Renaissance in painting. I think that sometimes people are quite lazy and very quick to pigeonhole things in their head because it's handy.

The idea of emotional content in your work is very important to you, but it often is a difficult subject to talk about. When you look back on that earlier work now, is it difficult for you to remember how you felt about it at the time? Recently, in a public interview [Green On Red Gallery, 13 December 2005], you felt it necessary to explain how much you believed in them, and still do.

Absolutely! One thing that came up in that interview was the connection between the emotional content of the work and the titles. So, for the purposes of this interview, I should point out that some of those earlier titles were the names of pop songs – *I can't get you out of my head* and *Come away with me*, for example. Some people may think that those titles were tongue-in-cheek and playful, but that wasn't my intention. They were heartfelt and genuine. The titles were really important. They were honest. They were about specific things that happened.

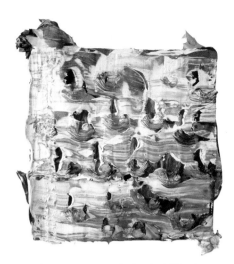

Maybe some people had difficulties with those paintings because of the titles. We've talked before about how the titles could have been misleading.

That work was shown mainly in Ireland in two solo shows in Dublin [2002 and 2004]. I think a lot of people were critical and felt they were misleading because they were made by a young painter and the works were a bit too full-on with those titles. Is there something Irish about that? We are not comfortable when people seem to be trying to be honest and emotionally connected to the making of artwork. I know that when the work was later exhibited in Basel [2003], people there were fascinated by the titles and thought they were incredibly appropriate. They had no problem with them, and the same in Germany [2004].

There is a lot of ironic work out there, and it was always likely or easy for people to latch onto those titles. In that environment, in that atmosphere of irony potentially, your work could be read that way. I'm not making a criticism of your decision. Why should you have to pander to that market?

If I have any regret about those titles, it is that they were not all my own words. I should not have used lyrics from pop songs, because what was personal to me was lost and appeared less genuine because of that connection with popular music.

Leaving aside the issue of titles, how did you hope to achieve an

engagement with emotion in that earlier work?

I think what Howard Hodgkin relies on to manifest emotion is to essentially break his paintings down into two elements – colour and mark. In some way these elements convey an emotional situation that Hodgkin had experienced. I certainly brought that forward into my paintings, which were essentially about those two elements, although the mark became incredibly physical.

I don't go along with that notion of being able to convey emotion through colour and mark. I don't understand it – it sounds too much like magic to me.

I think you have to be in a particular kind of emotional place or state to be able to do it and believe in it. I go in and out of phases of believing in it. For example, I'm really excited about the forthcoming Hodgkin show at IMMA, whereas a few months ago I wouldn't have been all that bothered.

I'm not making a claim that within painting I don't ever feel some heightened level of sensation, but it's such a subjective thing. It seems more dependent on the viewer than the artist. It's what the viewer brings to it.

Doesn't a lot of it come down to honesty and integrity on the artist's behalf? If you're going to accept that the idea of emotion can be realised in a painting at all, initially you have to believe in the artist's honesty and integrity. You don't have to even feel that it's interesting for you, or even good, but believing in that intention in some way allows you to engage with it. Let's take a Hodgkin – the title could be *Waking up in Naples* or *Venice*, or something. In some way you have to believe that Hodgkin is genuinely making a painting about that experience. You first have to be at that level before you can get anything in regards to the emotional content.

I don't know about 'believing', but surely an artist's integrity and honesty of emotion is a construct. I think it's a construct by the viewer, and that it's often based on very little or incidental information. I would always be doubtful as to whether or not I

know, and therefore I can't really bring myself to believe. Instead you have to take that leap of faith, and say 'I believe in the honesty and integrity of this artist and so I'll give myself the opportunity to believe in the work.' But I think an artist can be full of integrity and still make work that can be read as disingenuous.

Your career seemed to take off after the MA. You had exhibited quite a lot before the MA, and in very different contexts, but things seemed to happen quite quickly after 2001. Do you think that the notion of novelty figured here, because the sheer volume of paint in your work would have made it appear very unusual to people.

I think it's absolutely undeniable that there was a novelty factor with that work. A lot of people saw the MA show and it didn't seem to matter whether the people coming in were just off the street or hardcore conceptual artists who were almost anti-painting. They all got a similar buzz. They had different levels of engagement with the work, looking at the edges and shaking their heads...

Did that novelty wear off after the first show?

No, not really. When I did the first show in the Green On Red Gallery [2002], people were coming in and looking at the paintings in shock and excitement. I think they were asking themselves, 'How is all that paint staying there?' Physically, the paintings weren't a lot different from the MA show. You could say they were more confident. There was even more of a virtuosity about them. They were riskier in the way that they used colour. There were two pieces in the 2004 show that were made of pure lumps of paint. So there was certainly a confidence appearing in the work from that point of view, but I think there was still a novelty factor.

I've no doubt that the first time I saw a Jason Martin or a Zebedee Jones, they were extremely novel to me. They were so odd-looking. I hadn't seen anything else like them before. The same occurred when I saw an Alexis Harding or a Michael Raedecker, although maybe in a less aggressive way. All of that

work has something distinctly different or odd about it – physically, in the way they are actually put together. There's always a novelty factor. I'm sure it was the same with those early Gary Hume paintings. It's the same with a lot of painting, I think. I don't know how you can avoid that initially, and I don't know that it's a bad thing. Okay, if it's the only thing that people are engaging with, I think that would be problematic. I don't know any painters that make work for the novelty factor, but I think that after a point it became a concern for me because sometimes it was difficult for people to get past that 'difference'.

When you look back on that period of time [2001-04], do you think that the public were more likely to be impressed and swept away by that work than other painters were?

Yes, I think so. It goes back to novelty again. It was just that they had never seen anything like them anywhere.

I suppose I'm actually thinking of a more simplistic reading of that relationship between people who do make paintings and people who don't make paintings. Other painters have an inherent knowledge of the material qualities of oil paint, of how thick it is and how luscious it is and how built-up it can be. But for a lot of people who don't make paintings and who have never been in a studio before, oil paint itself can be a relatively mysterious substance.

Fallen star
2004, oil on linen over
board, 30.5 x 30.5 cm

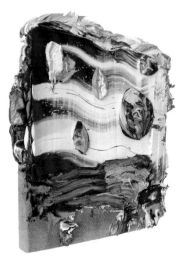

If the older work was connected to the technical achievement of building up a surface and arriving at a point that is really unusual, it seems that some of these ideas are redundant in your recent work and that your concept of technique has changed. Is that happening through stages or was there a very particular point in time when you changed?

I think that the technique or the approach to making the paintings changed gradually. I got to a point where I wanted to make paintings that were more demanding of the viewer and of me. The intensity of my time in the studio seemed to reflect this ambition: I was quite happy to be locked away in complete concentration and engagement. Gradually the paintings started to reflect many different concerns and ideas that I was interested in – emotion, physical experience, intimacy, and the complexity of space, isolation and so on. The idea of being isolated to make the paintings is important to me... not complete isolation – obviously engaging with the world is of great importance to an artist. But it certainly felt that this self-imposed isolation was the only way that I could make paintings, the only way that felt meaningful.

So, that's the only approach you feel comfortable with at the moment. Otherwise, it might seem half-hearted.

Yes, I think so. I think it's the only way that I can make the paintings, and it's the only way that I can believe in them. I'm not putting it up on a pedestal as the only way you can do things. It seems to me that within contemporary painting the approach can be sometimes flippant and simply of the moment. I think it's all of these concerns and ideas about contemporary painting that connected me more to older painters of the late Gothic / early Renaissance period. My approach to the work and relationship with it is very much informed by the person I am. It's important for me that what I do is not influenced by fashion. In that regard, my relationship to my work is a lot more conceptual than it may seem.

I think there are often a lot more concepts inherent in the practice of making the work than people realise, that it's not one without the other – concept or technique.

Yes, I agree with that. For me, practical and conceptual concerns are inseparable. We live in a world that is more easily defined by technology, but I am interested in ideas about the handmade, how human existence can be communicated through the handmade in a more meaningful way. There is a real difference between process paintings and painting that emphasises the presence of the human hand. For me, the latter is a more conceptual approach. I think ideas about the handmade have an important role to play in a contemporary context.

The notion of the 'accidental' and physical at play in the older work contrasts with the approach to your recent paintings, which are more 'painted'. For all the control you exercised, there was always the possibility of arriving at an unexpected point with any given painting. The current work seems more intent in terms of descriptive painting; even the empty areas in the current work seem much more premeditated.

Well, not really. My current paintings start out with a very specific intention, which usually changes as a dialogue develops between the work and me. So, I think that premeditation is the wrong word because it implies that there is no room for the unplanned, the change of mind. These are now an important part of my practice.

Mark Swords is an artist who lives and works in Wicklow. He has a Masters degree from NCAD and his work has been exhibited in Dublin, London and New York.

COLOUR PLATES

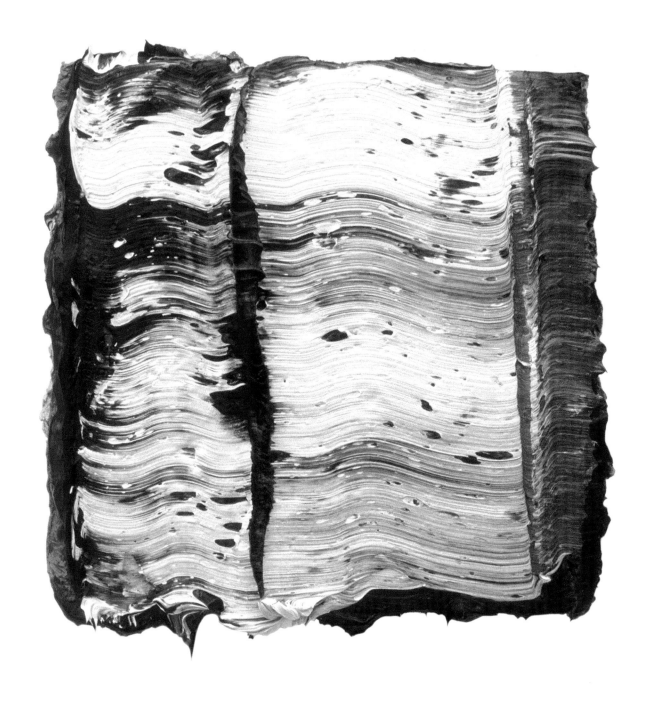

Gem
2001, oil on canvas over board, 30.5 x 30.5 cm

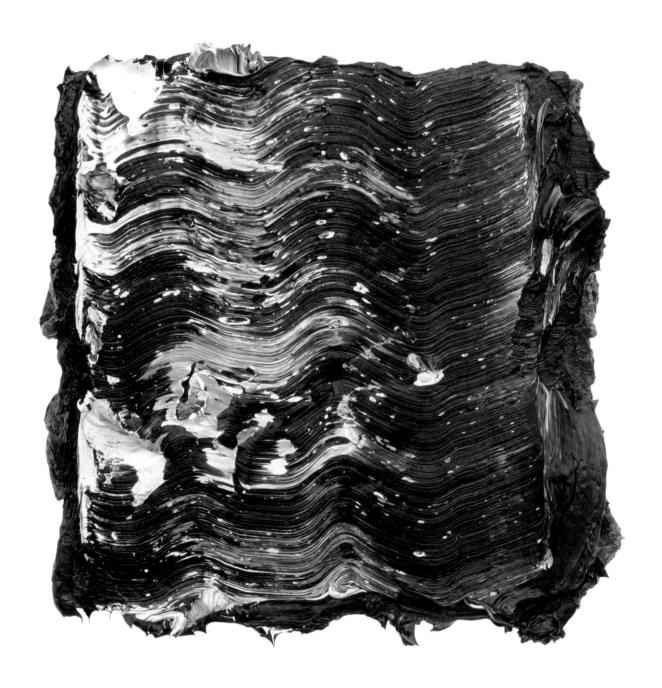

Cracker
2001, oil on canvas over board, 30.5 x 30.5 cm

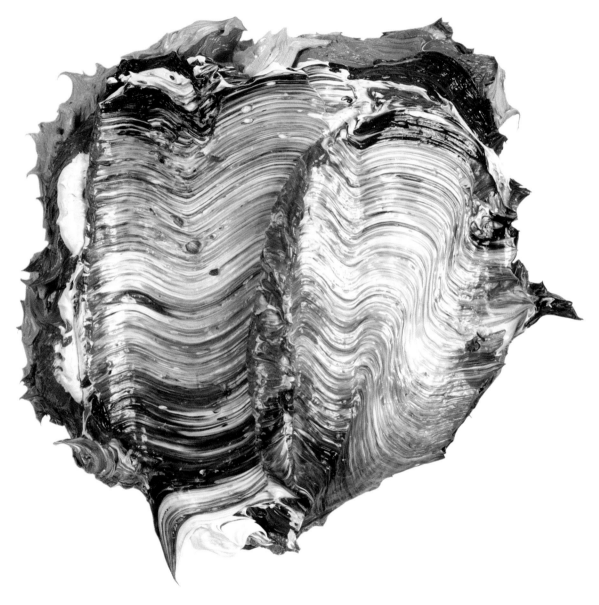

Fragile
1999-2002, oil, 23.5 x 23.5 cm

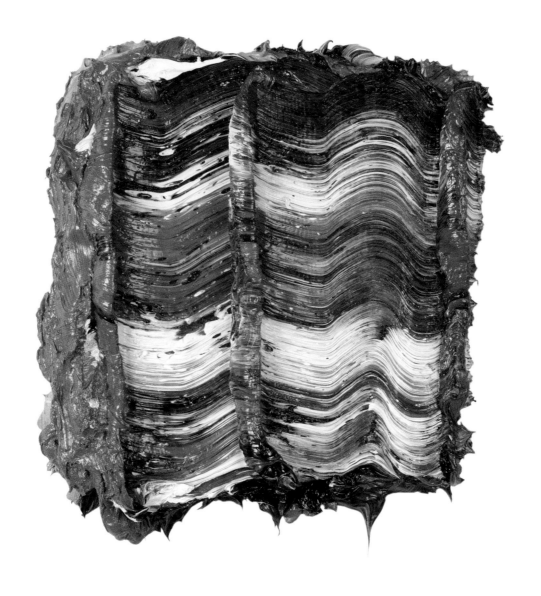

Gorgeous
2002, oil on canvas over board, 23 x 23 cm

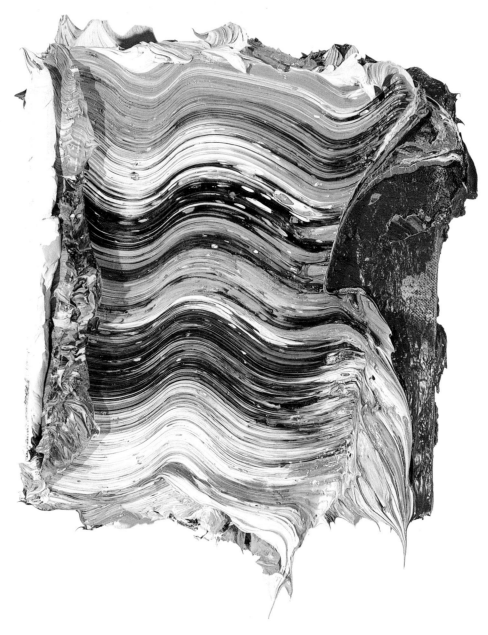

Banjaxed
2002, oil on canvas over board, 23 x 23 cm

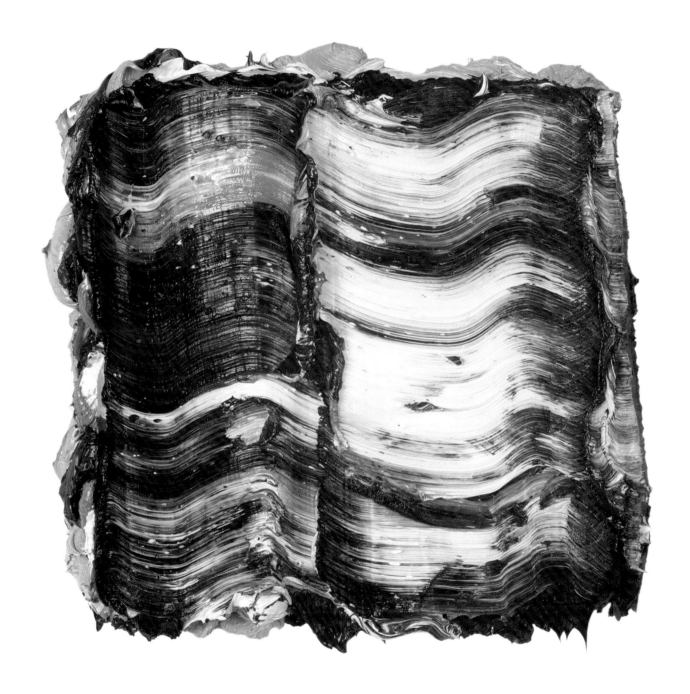

Star
2002, oil on canvas over board, 30.5 x 30.5 cm

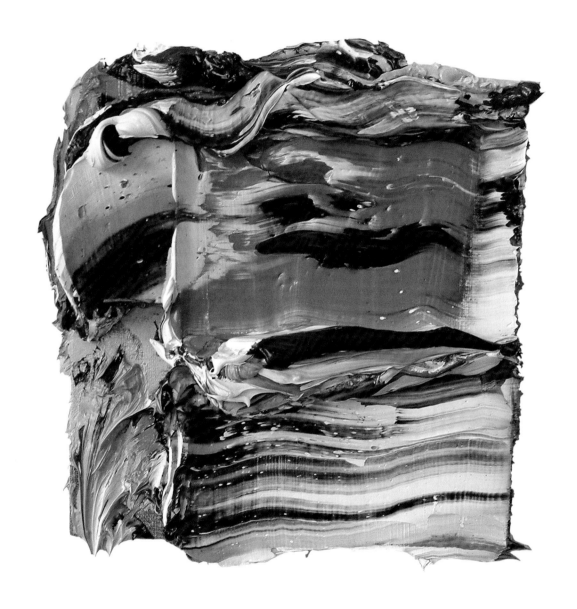

Magic moment
2002, oil on canvas over board, 23 x 23 cm (Office of Public Works)

Vitamin P
2003, oil on linen over board, 30.5 x 30.5 cm

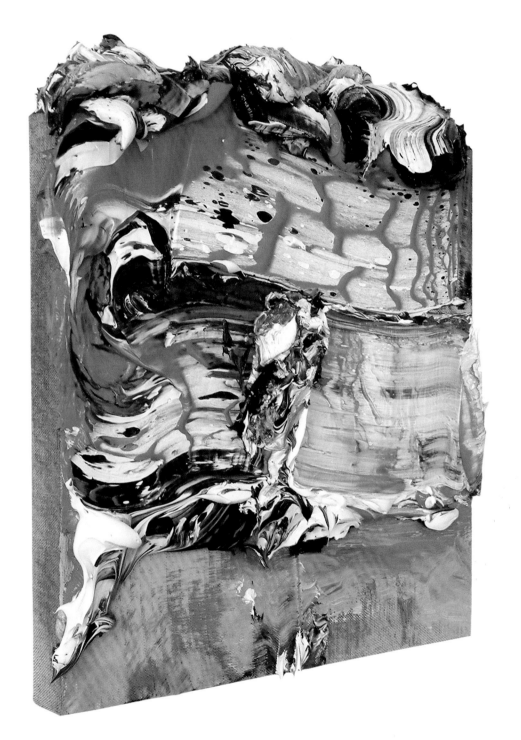

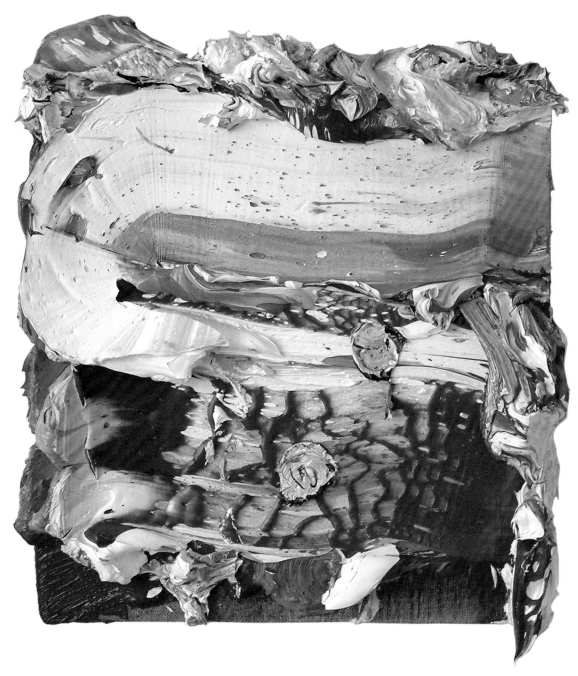

Fairytale
2003, oil on linen over board, 30.5 x 30.5 cm

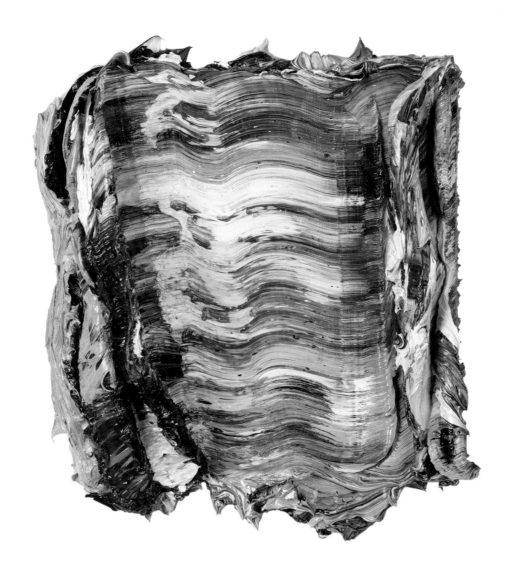

Skater
2002, oil on canvas over board, 23 x 23 cm

What a feeling
2002-03, oil on canvas over board, 23 x 23 cm

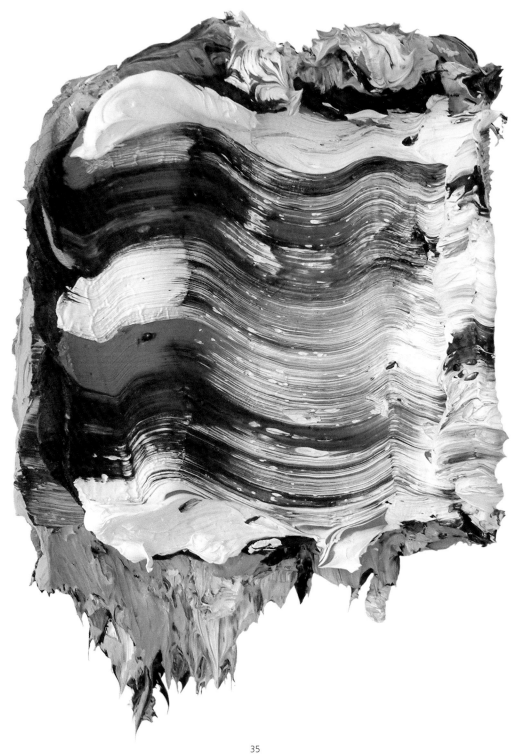

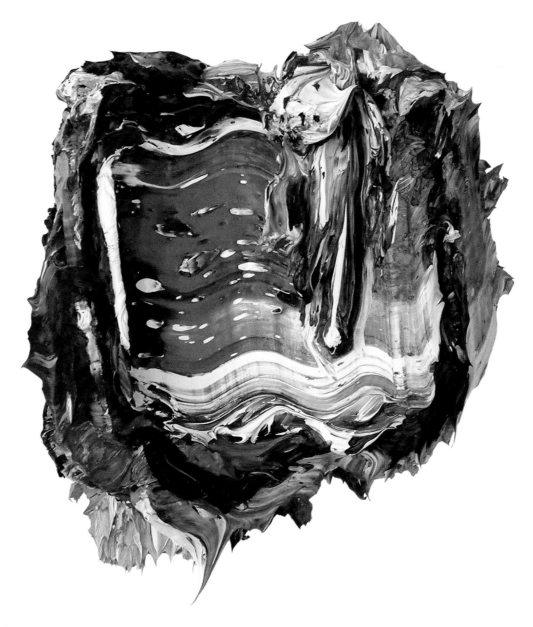

I don't know why
2003, oil on linen over board, 23 x 23 cm

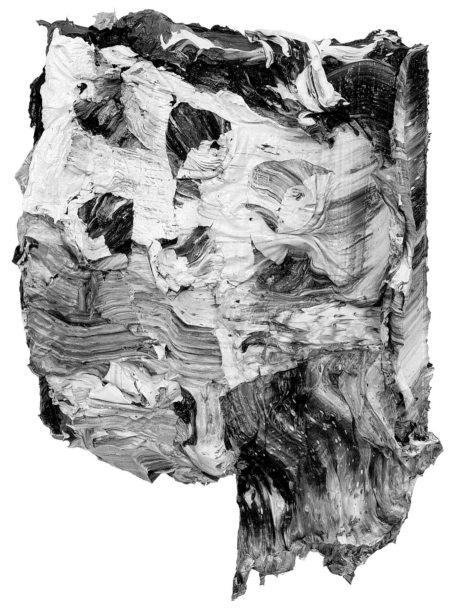

Surgery
2003, oil on linen over board, 23 x 23 cm

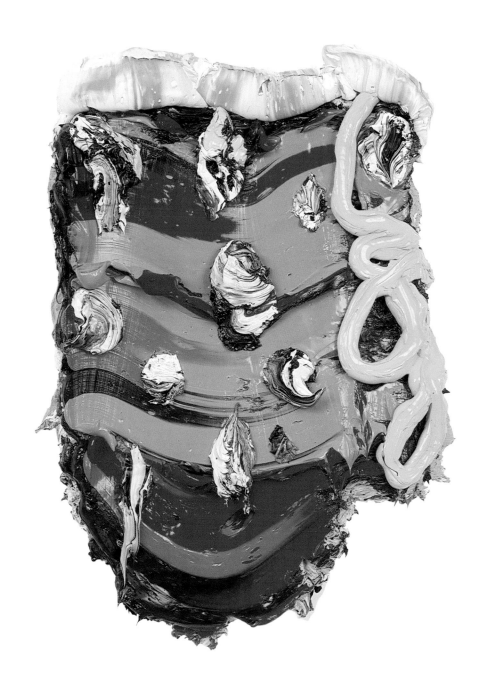

Bright smile
2002-03, oil on linen over board, 23 x 23 cm (Bank of Ireland Art Collection)

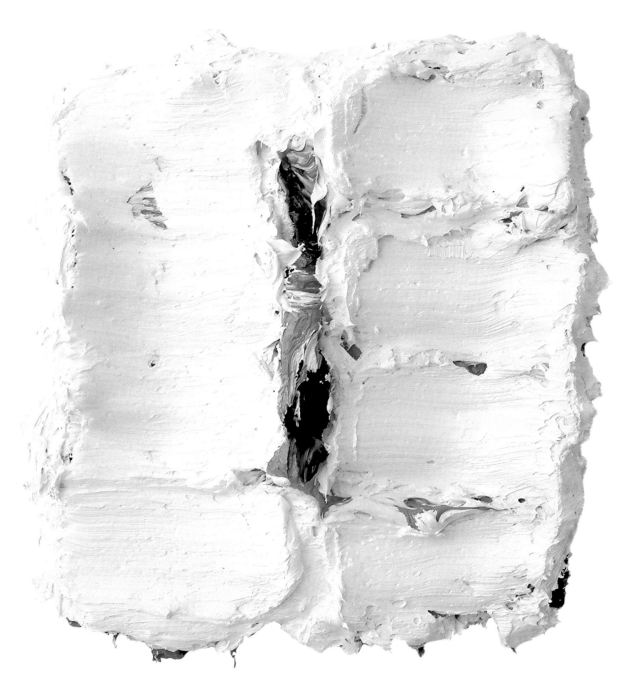

Talking about art
2001-03, oil on canvas over board, 30.5 x 30.5 cm

I can't get you out of my head
2003, oil on linen over board, 42 x 42 cm

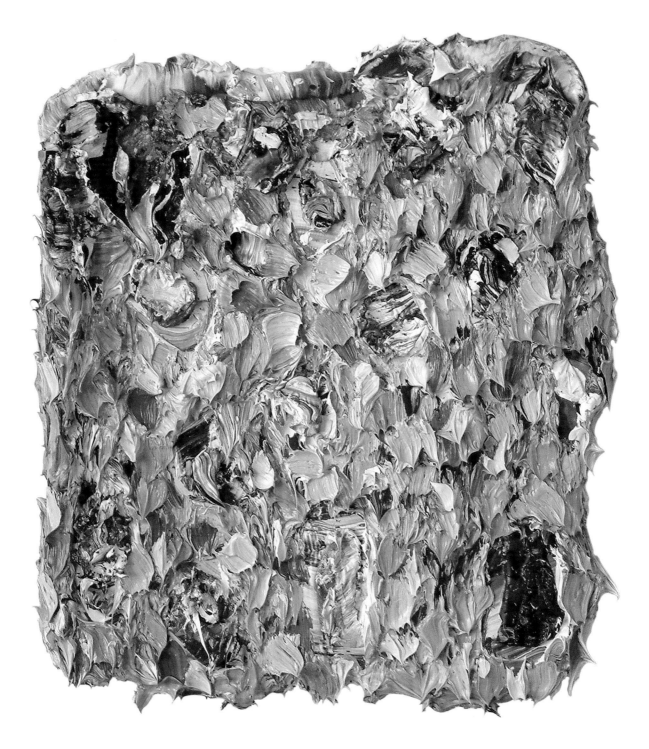

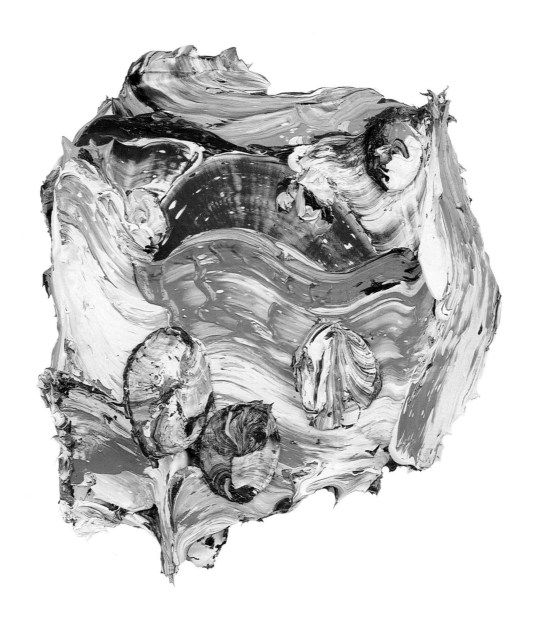

Wonderful, wonderful
2003, oil on linen over board, 23 x 23 cm

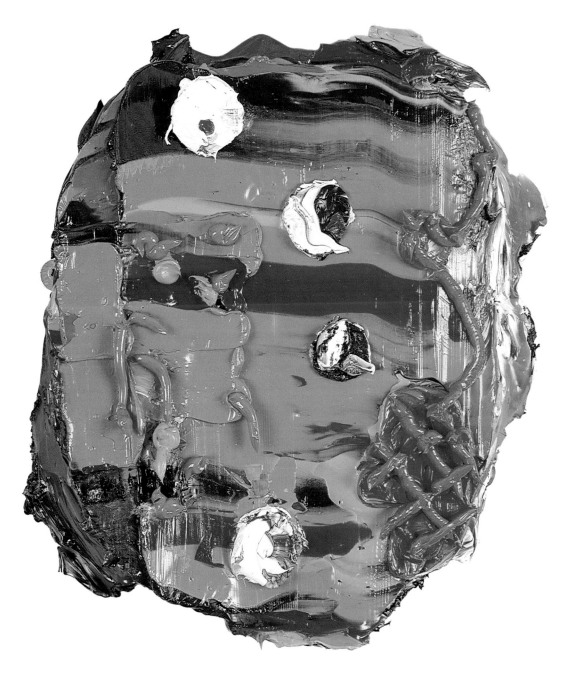

Leave it alone
2001-03, oil, 30 x 25 cm

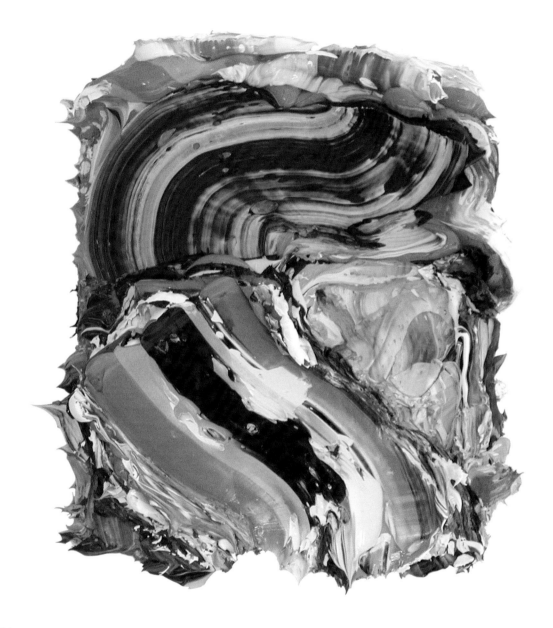

You sexy thing
2003, oil on linen over board, 23 x 23 cm

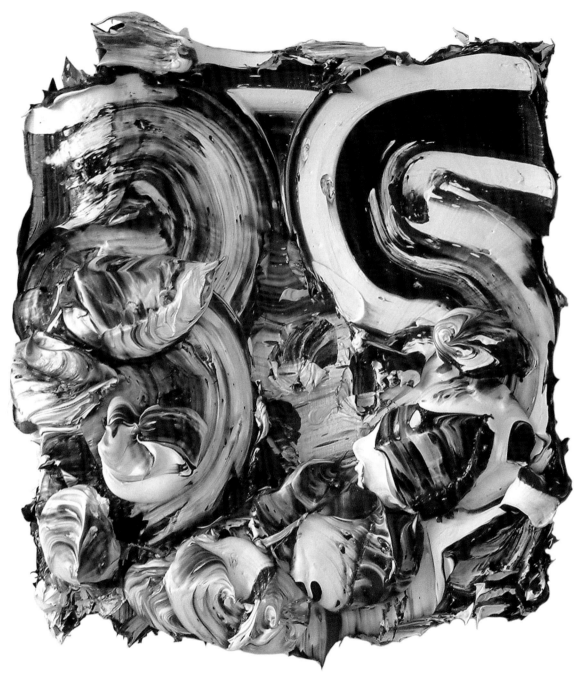

Cry me a river
2003-04, oil on linen over board, 30.5 x 30.5 cm

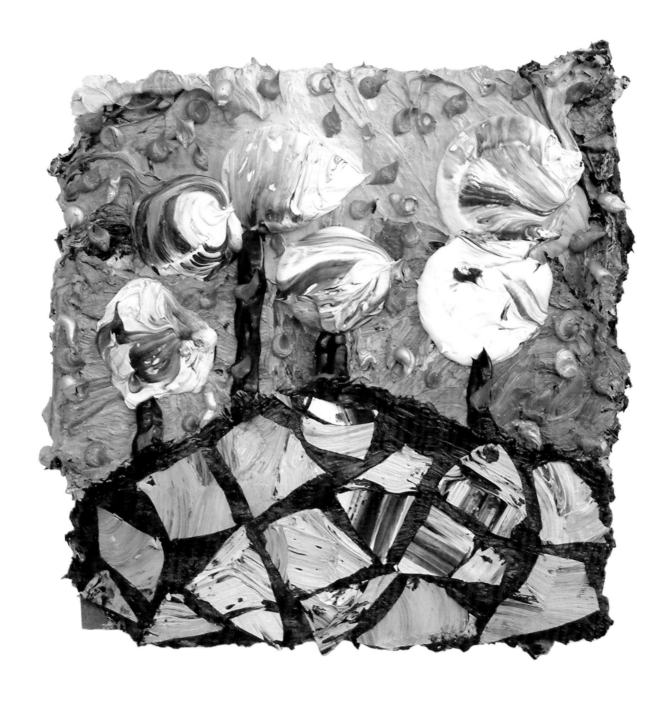

Long ago
2005, oil on linen over board, 30.5 x 30.5 cm

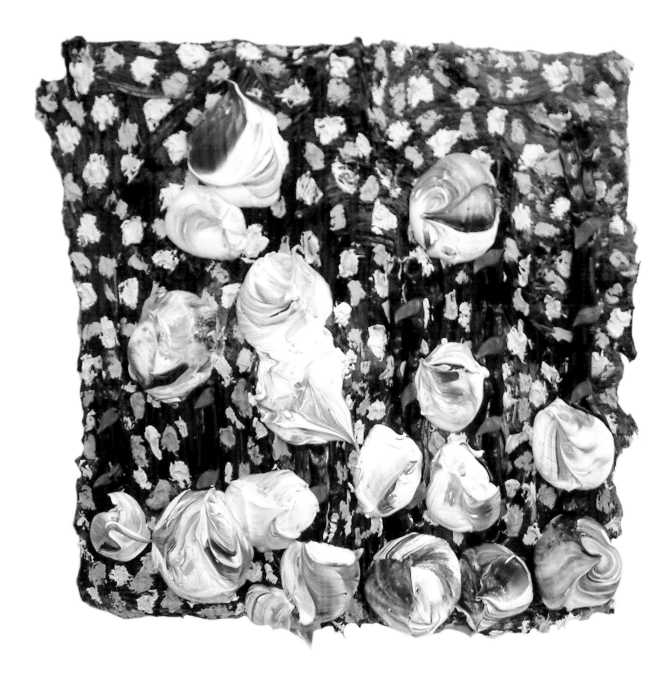

Classic
2004, oil on linen over board, 30 x 30 cm

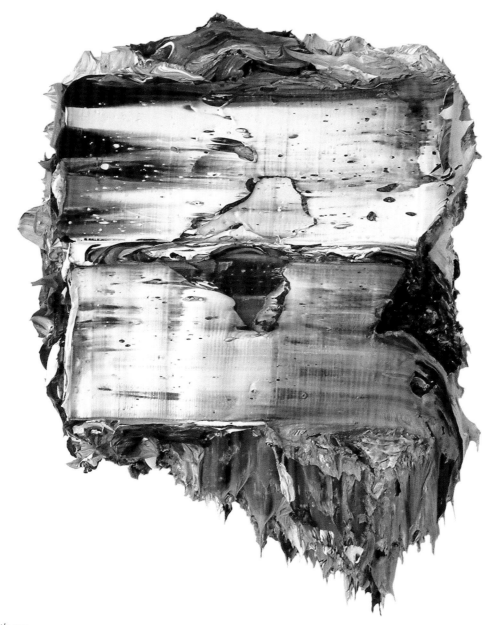

Come away with me
2003, oil on canvas over board, 23 x 23 cm

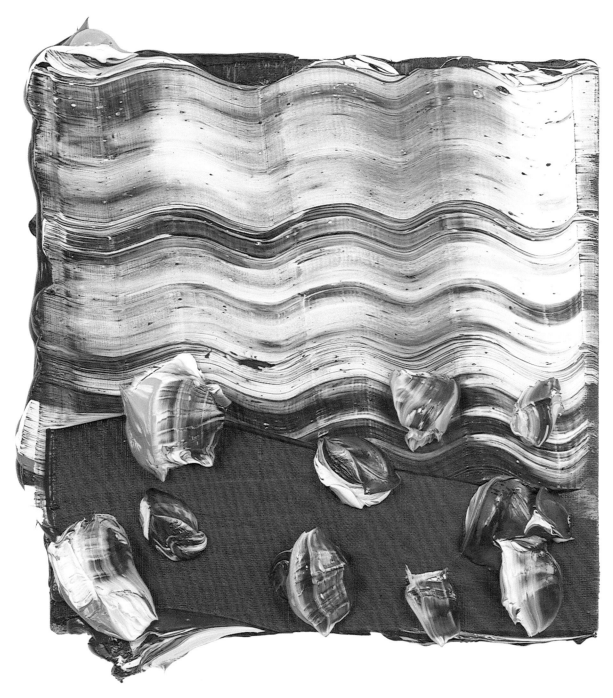

Little emotions
2003, oil on linen over board, 30.5 x 30.5 cm

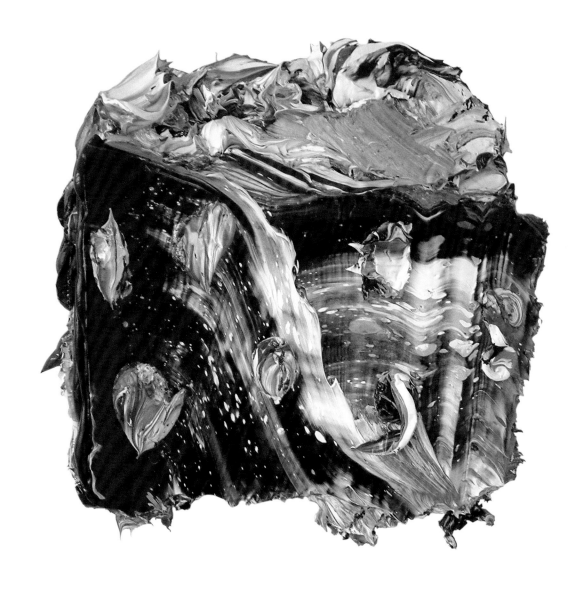

Fireworks
2003, oil on linen over board, 23 x 23 cm (Dublin Dental School and Hospital)

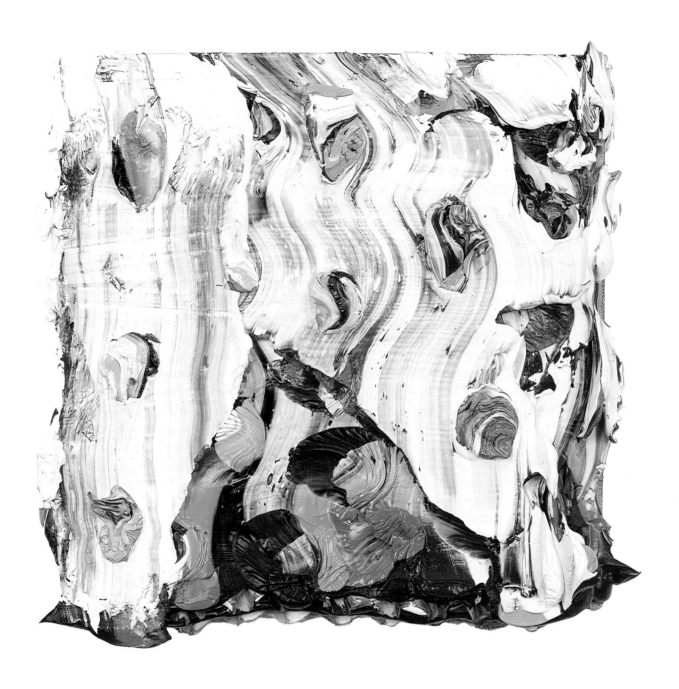

Yes, yes, yes
2003, oil on linen over board, 30.5 x 30.5 cm

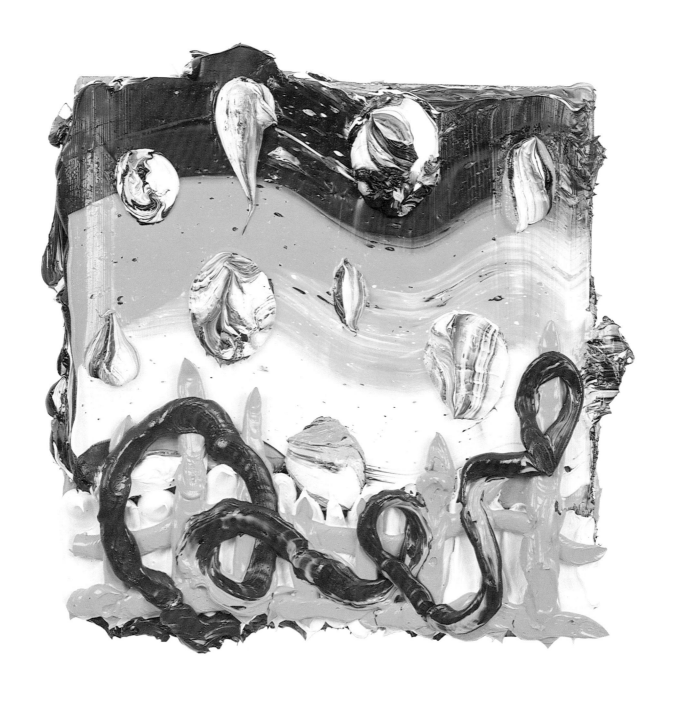

Mad world
2003, oil on linen over board, 30.5 x 30.5 cm

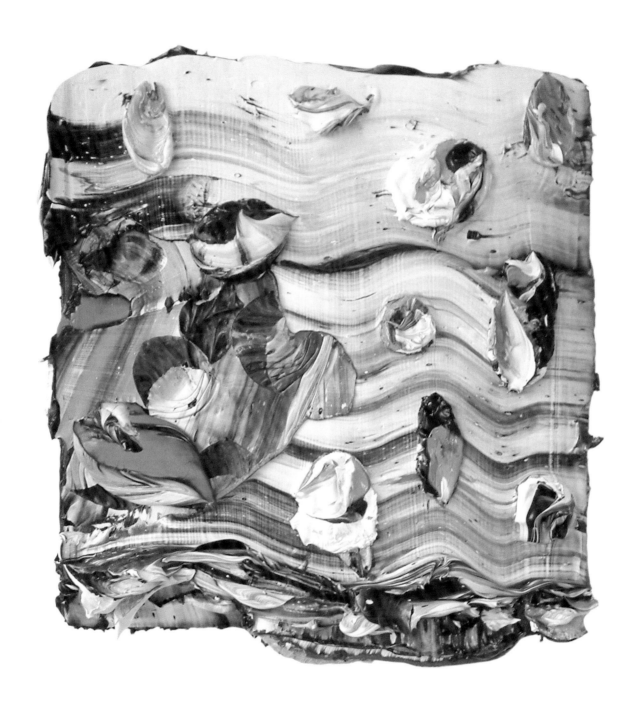

Talking to Uccello
2001-03, oil on linen over board, 30.5 x 30.5 cm

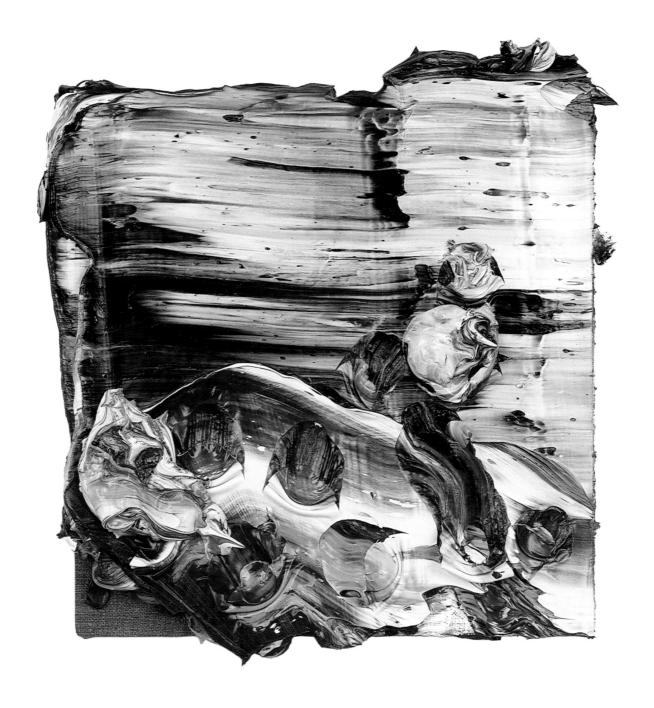

Friedrich, Yeats, Cecily and I
2003, oil on linen over board, 30.5 x 30.5 cm

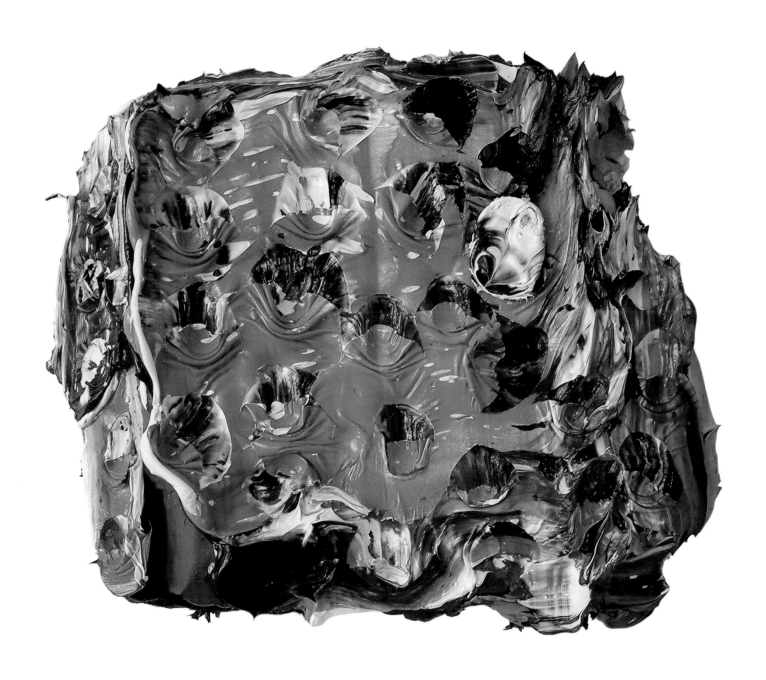

The closest thing to crazy
2003-04, oil on linen over board, 30.5 x 30.5 cm

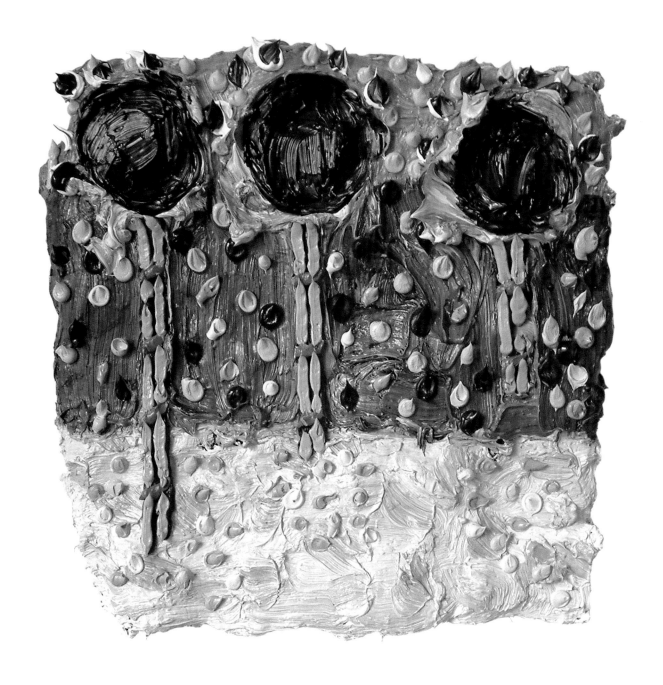

Remember
2004, oil on linen over board, 30.5 x 30.5 cm (Marc and Livia Straus Family Collection, USA)

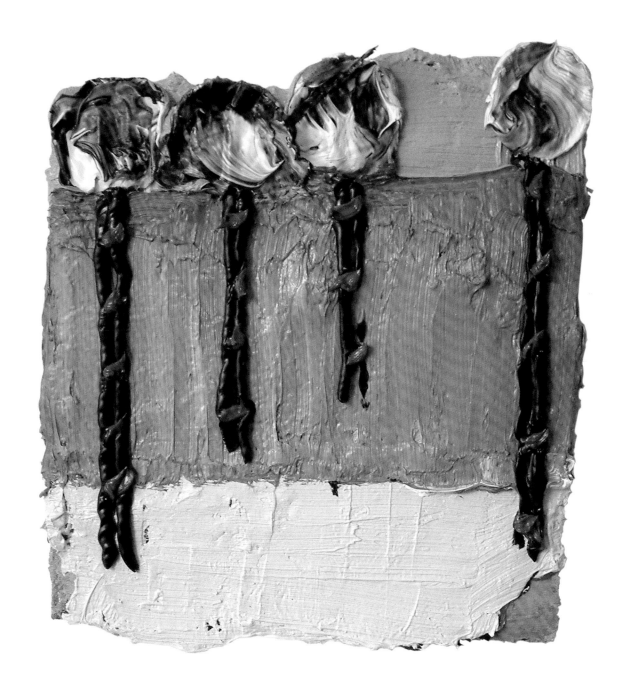

Giotto
2004, oil on linen over board, 30.5 x 30.5 cm (Marc and Livia Straus Family Collection, USA)

Untitled
2005, oil on linen over board, 66 x 52.5 cm

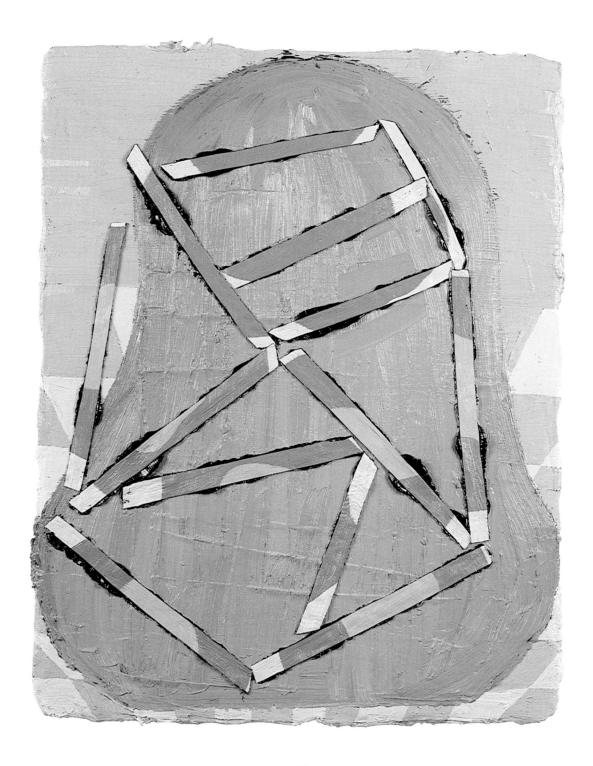

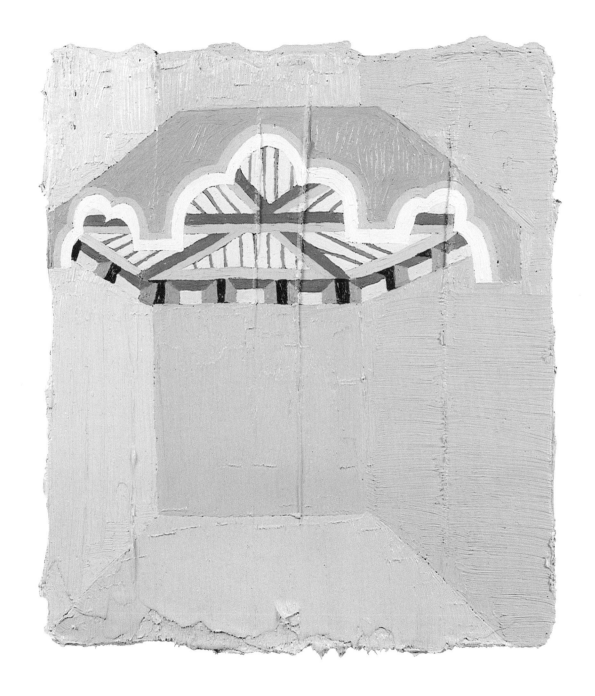

Untitled
2005, oil on linen over board, 38.5 x 33.5 cm

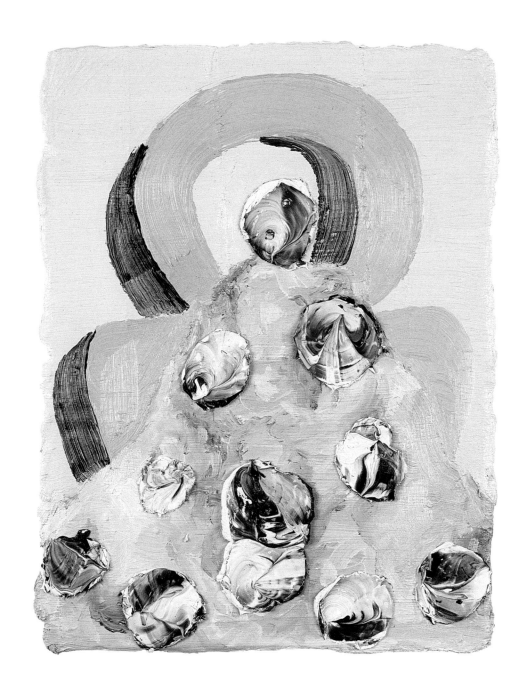

Untitled
2006, oil on linen over board, 40 x 30 cm

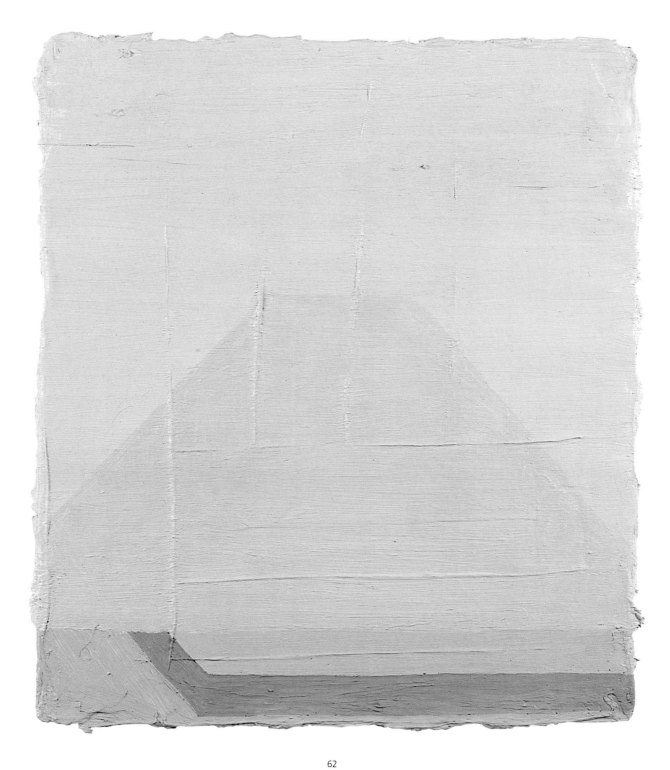

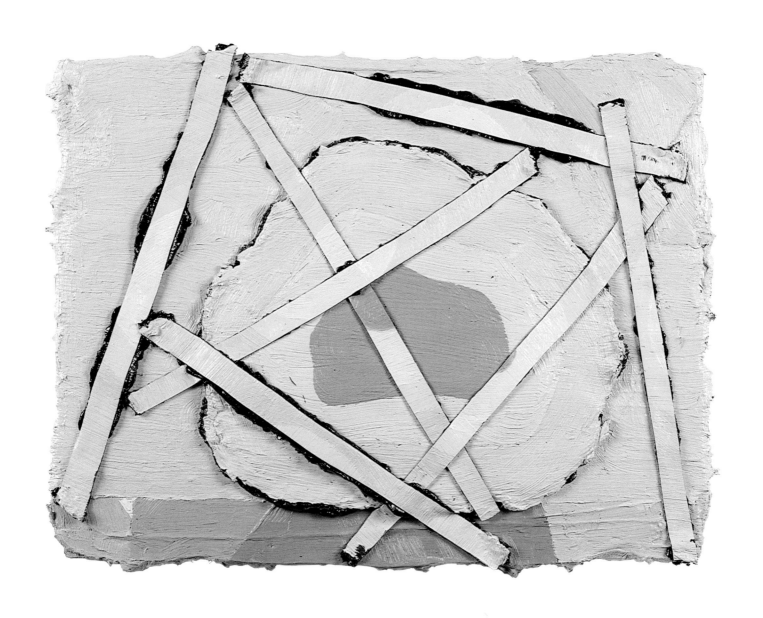

Untitled
2005, oil on linen over board, 52 x 46.5 cm (Office of Public Works)

Untitled
2005, oil on linen over board, 30 x 40 cm

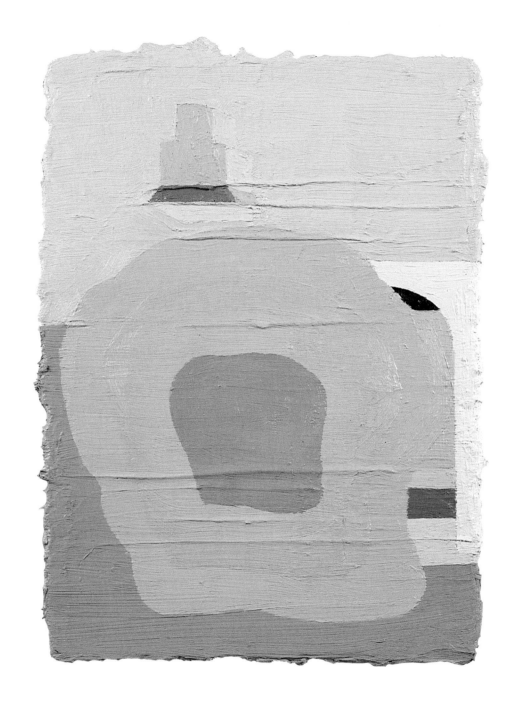

Untitled
2005, oil on linen over board, 40 x 30 cm

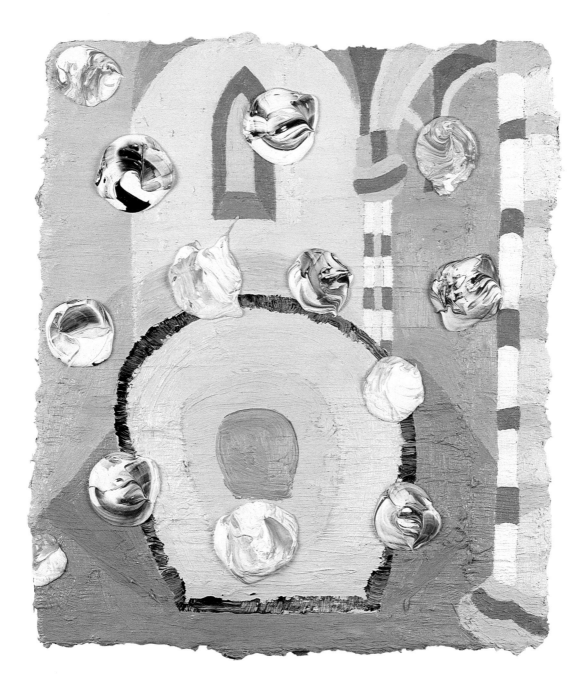

Untitled
2006, oil on linen over board, 40 x 35 cm

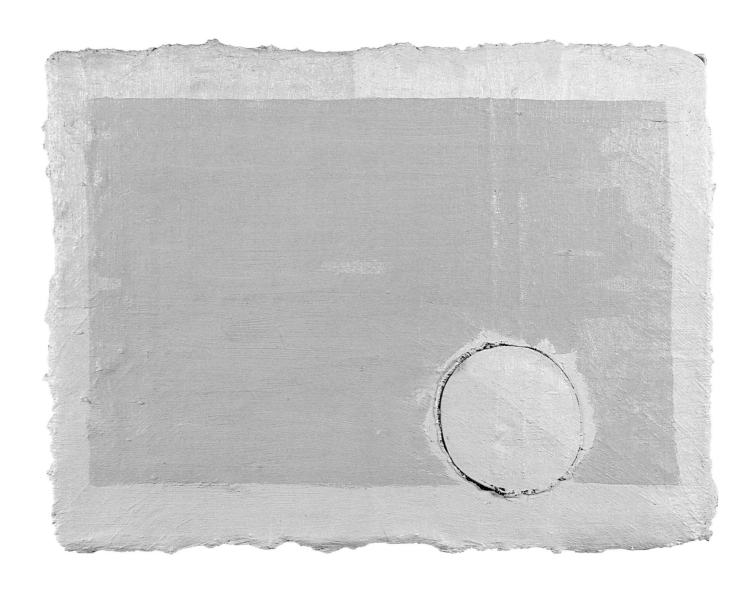

Untitled
2005, oil on linen over board, 35.5 x 52 cm

Untitled
2006, oil on linen over board, 63.5 x 53.5 cm

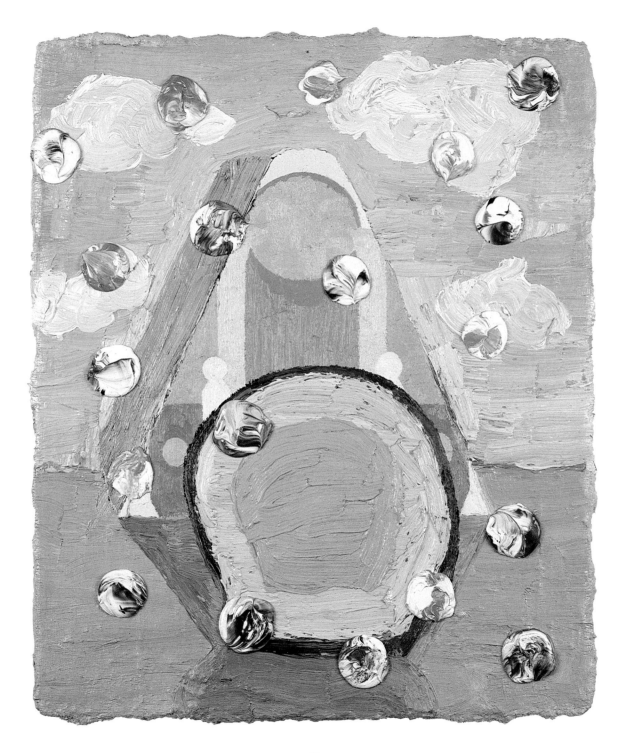

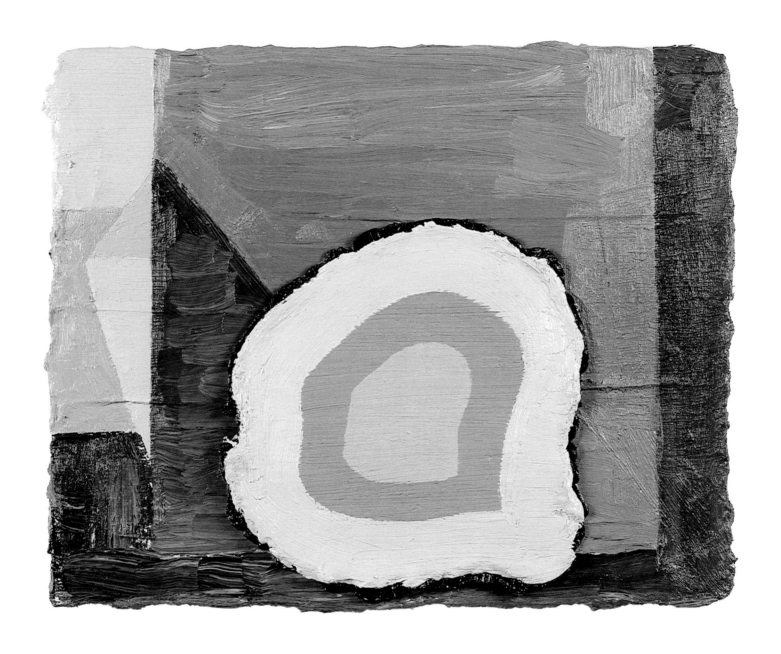

Untitled
2005, oil on linen over board, 42 x 53 cm

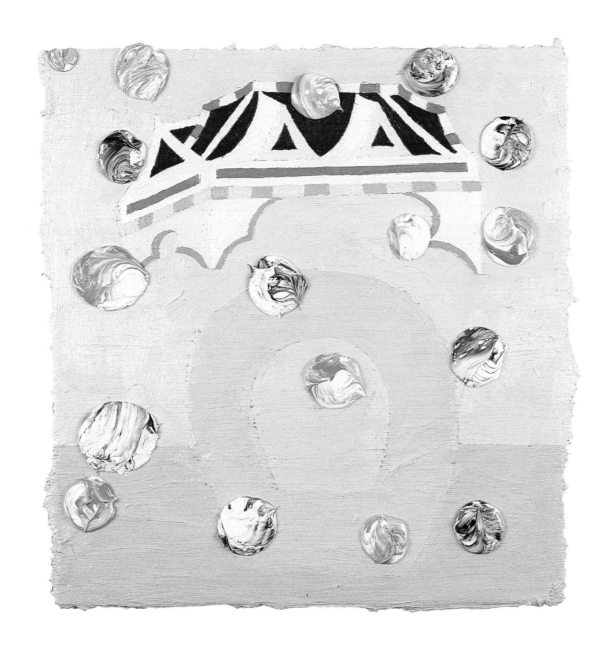

Untitled
2006, oil on linen over board, 42 x 40 cm

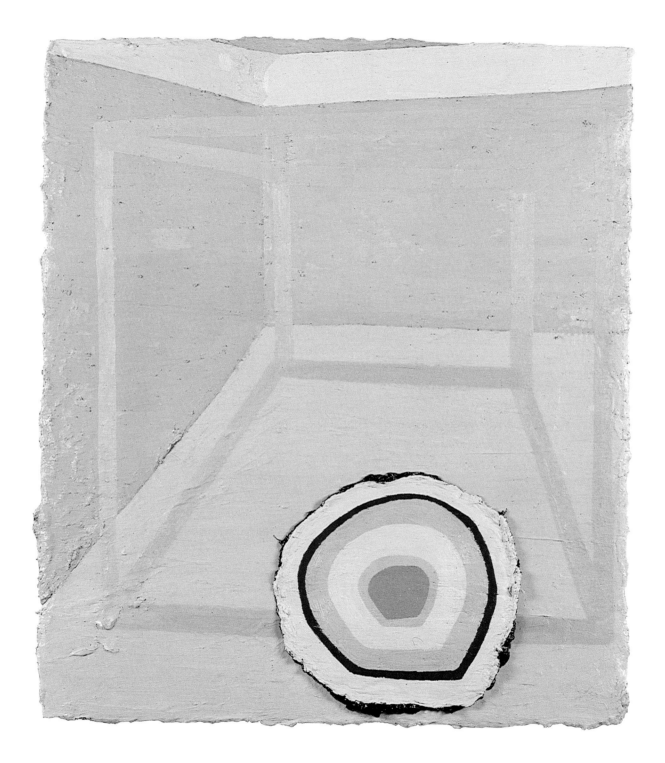

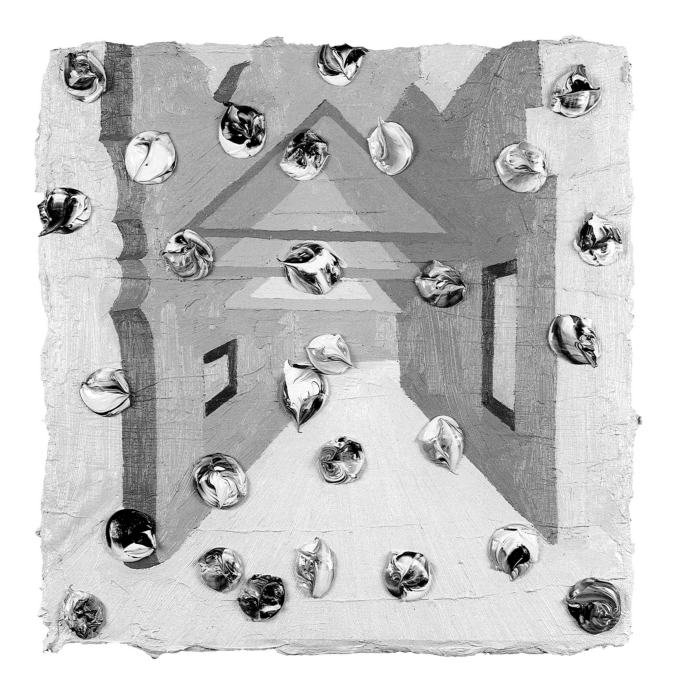

Untitled
2005, oil on linen over board, 90 x 80 cm

Untitled
2006, oil on linen over board, 46.5 x 46 cm

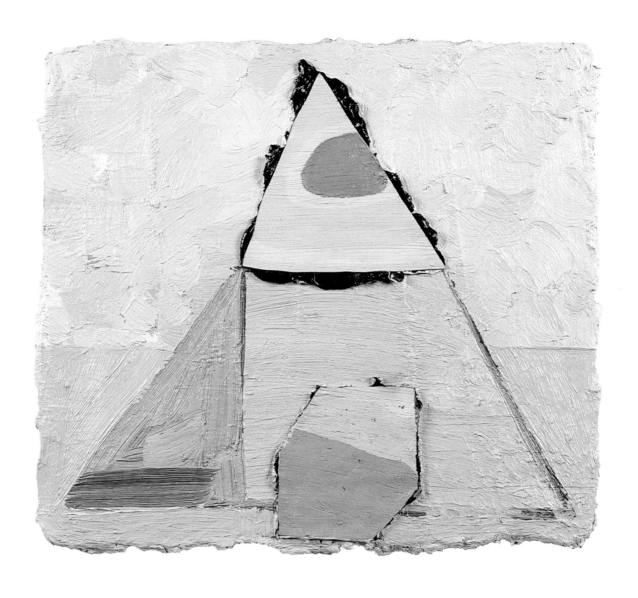

Untitled
2005, oil on linen over board, 36 x 41 cm

Untitled
2006, oil on linen over board, 47 x 52 cm

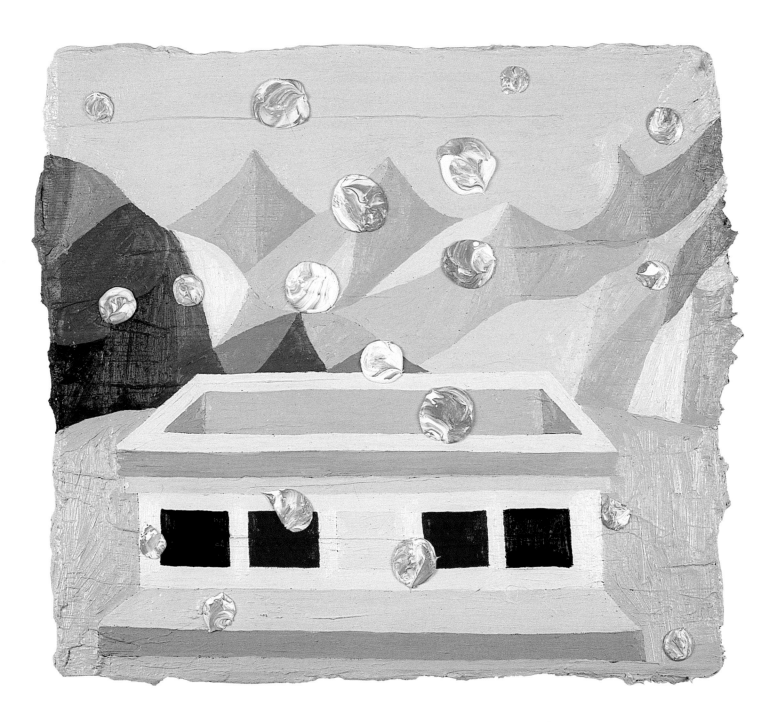

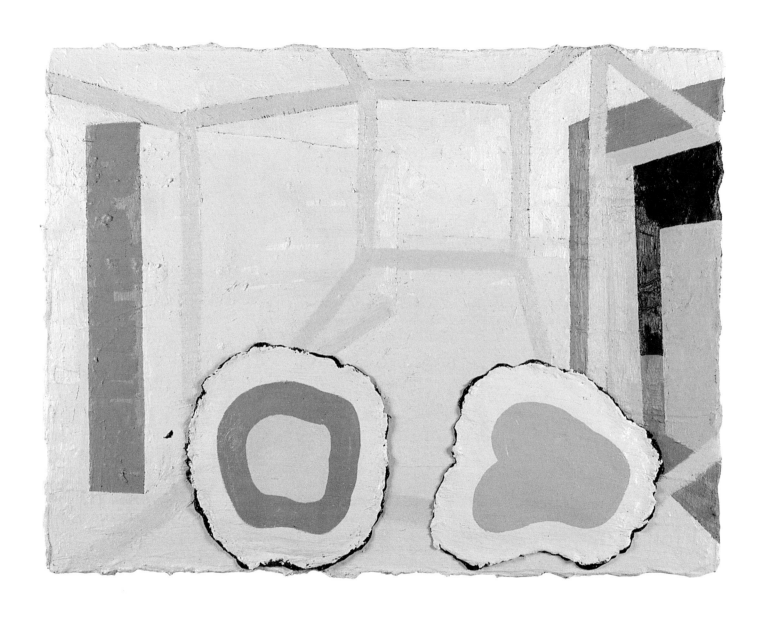

Untitled
2005, oil on linen over board, 75 x 100 cm

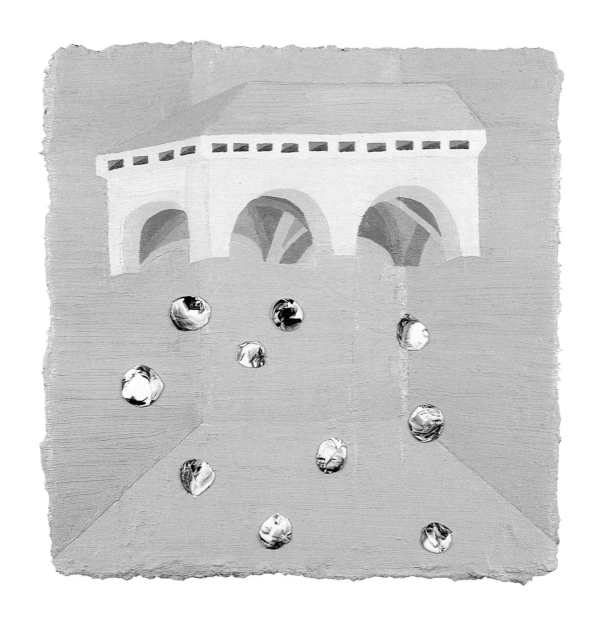

Untitled
2006, oil on linen over board, 50.5 x 50 cm

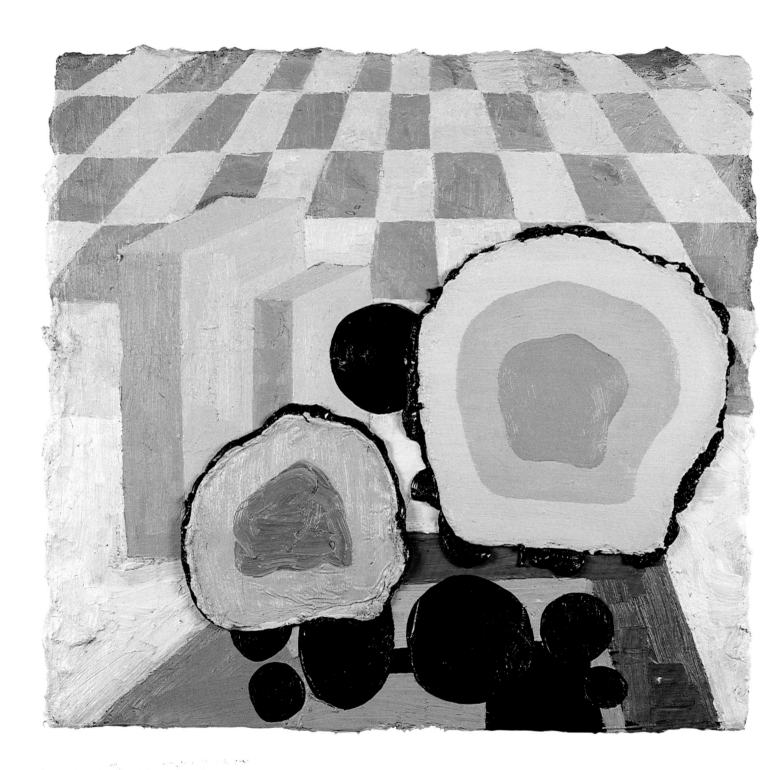

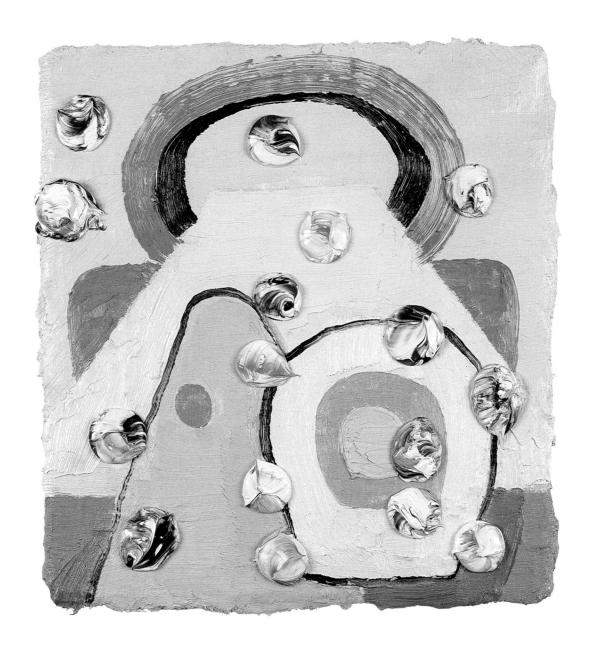

Untitled
2005, oil on linen over board, 66.5 x 71 cm

Untitled
2006, oil on linen over board, 42 x 40 cm

45	*Cry me a river*
	2003-04, oil on linen over board, 30.5 x 30.5 cm (private collection, USA)
46	*Long ago* 2005, oil on linen over board, 30.5 x 30.5 cm (private collection)
47	*Classic* 2004, oil on linen over board, 30 x 30 cm (private collection)
48	*Come away with me* 2003, oil on canvas over board, 23 x 23 cm (private collection)
49	*Little emotions* 2003, oil on linen over board, 30.5 x 30.5 cm (private collection)
50	*Fireworks* 2003, oil on linen over board, 23 x 23 cm (Dublin Dental School & Hospital)
51	*Yes, yes, yes* 2003, oil on linen over board, 30.5 x 30.5 cm (private collection, USA)
52	*Mad world*
	2003, oil on linen over board, 30.5 x 30.5 cm (private collection, Hong Kong)
53	*Talking to Uccello*
	2001-03, oil on linen over board, 30.5 x 30.5 cm (private collection)
54	*Friedrich, Yeats, Cecily and I*
	2003, oil on linen over board, 30.5 x 30.5 cm (private collection)
55	*The closest thing to crazy*
	2003-04, oil on linen over board, 30.5 x 30.5 cm (private collection, The Netherlands)
56	*Remember*
	2004, oil on linen over board, 30.5 x 30.5 cm (Marc and Livia Straus Family Collection, USA)
57	*Giotto*
	2004, oil on linen over board, 30.5 x 30.5 cm (Marc and Livia Straus Family Collection, USA)
59	*Untitled* 2005, oil on linen over board, 66 x 52.5 cm *
60	*Untitled* 2005, oil on linen over board, 38.5 x 33.5 cm (private collection)
61	*Untitled* 2006, oil on linen over board, 40 x 30 cm *
62	*Untitled* 2005, oil on linen over board, 52 x 46.5 cm (Office of Public Works)
63	*Untitled* 2005, oil on linen over board, 30 x 40 cm *
64	*Untitled* 2005, oil on linen over board, 40 x 30 cm (private collection)
65	*Untitled* 2006, oil on linen over board, 40 x 35 cm *
66	*Untitled* 2005, oil on linen over board, 35.5 x 52 cm (private collection)
67	*Untitled* 2006, oil on linen over board, 63.5 x 53.5 cm *
68	*Untitled* 2005, oil on linen over board, 42 x 53 cm (private collection)
69	*Untitled* 2006, oil on linen over board, 42 x 40 cm *
70	*Untitled* 2005, oil on linen over board, 90 x 80 cm (private collection)
71	*Untitled* 2006, oil on linen over board, 46.5 x 46 cm *
72	*Untitled* 2005, oil on linen over board, 36 x 41 cm (private collection)
73	*Untitled* 2006, oil on linen over board, 47 x 52 cm *
74	*Untitled* 2005, oil on linen over board, 75 x 100 cm *
75	*Untitled* 2006, oil on linen over board, 50.5 x 50 cm *
76	*Untitled* 2005, oil on linen over board, 66.5 x 71 cm (private collection)
77	*Untitled* 2006, oil on linen over board, 42 x 40 cm *

* courtesy the artist and Green On Red Gallery

PAUL DORAN

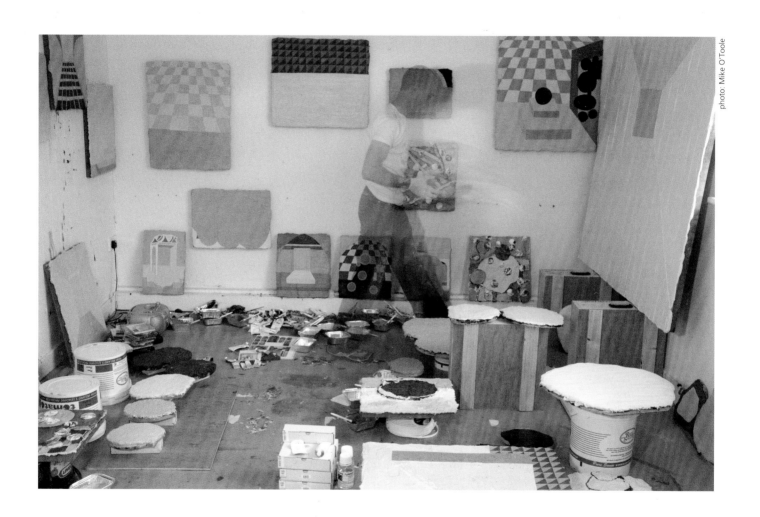

photo: Mike O'Toole

1972	Born in Gorey, Co Wexford
1993-01	National College of Art & Design, Dublin: BA Fine Art, Painting (1993-97), HDip, ADT (1997-98); MA Fine Art (1999-2001)
1997	CAP Foundation, shortlisted award
2005	AIB Art Prize
	Lives and works in Gorey, Co Wexford

SOLO EXHIBITIONS

2006	*Man in a shed*, Sligo Art Gallery
2005	*Gislebertus told me*, Green On Red Gallery, Dublin
2004	Green On Red Gallery, Dublin
	Finesilver Gallery, San Antonio, Texas
2002	Green On Red Gallery, Dublin
	Zella Gallery, London
1999	Hallward Gallery, Dublin
	Tinahely Arts Centre, Co Wicklow
	Kilcock Art Gallery, Co Kildare
	Kilkenny Arts Festival
	Wexford Opera Festival

SELECTED GROUP EXHIBITIONS

2005	NADA Miami Art Fair, Miami
	FIAC Art Fair, Paris
	two d, Green On Red Gallery, Dublin
	Stitching Rotterdam, Rotterdam
	New Territories, Arco, Madrid
	Siar 50 – 50 Years of Irish Art from the Collections of the Contemporary Irish Arts Society, IMMA, Dublin
	Contemporary Art from Ireland, European Central Bank, Frankfurt
2004	Galerie Tanya Rumpff, Haarlem (also 2002)
	Galerie Michael Stürm, Stuttgart
2003	*Colour Chart*, Ormeau Baths Gallery, Belfast
	Totgeasgte leben länger, Galerie Ulrich Mueller, Cologne
	Art Cologne 2003, Cologne (also 2001, 2002)
	Malerei?, Galerie Katharina Krohn, Basel
	Art Chicago
	ART2003, London Art Fair
2002	*The Armory Show*, New York
2001	*Contemporary 2001*, Green On Red Gallery, Dublin
	NCAD MA Graduate Show, Hugh Lane Gallery, Dublin

SELECTED BIBLIOGRAPHY

2006	John O'Regan (ed), *Profile 24 – Paul Doran*; also published in hardback as *Man in a shed* (Gandon)
	'Round-Up: Paul Doran @ Green On Red', *Visual Artists' News Sheet* °1, Jan-Feb
	Eimear McKeith, 'Gislebertus told me', *Circa* °115
2005	Eimear McKeith, 'Getting down to the essence', *Sunday Tribune*, 11 Dec
	Aidan Dunne, 'Gislebertus told me', *Irish Times*, 30 Nov
	'The Business of Painting', interview, *Visual Artists' News Sheet* °5, Sept-Oct
2004	*Paul Doran*, essays by Enrique Juncosa and Jens-Peter Koerver (Green On Red Gallery, Dublin; Finesilver Gallery, San Antonio; Galerie Katharina Krohn, Basel)
	Marianne Hartigan, 'Luscious', *Sunday Tribune*, 29 Feb
	Aidan Dunne, 'Big paintings in small parcels', *Irish Times*, 20 Feb
2002	Aidan Dunne, 'Objects of Obsession', *Irish Times Magazine*, 22 June
1999	*Paul Doran*, essay by Aidan Dunne (Hallward, Dublin)

SELECTED PUBLIC & CORPORATE COLLECTIONS – AIB Group; AXA Insurance; Bank of Ireland; Enterprise Ireland; Intel; Irish Museum of Modern Art; KPM Amro; National College of Art & Design; Office of Public Works; University College Dublin; Wesley College, Dublin; Wyeth Pharmaceuticals

Paul Doran is represented by the Green On Red Gallery, 26-28 Lombard Street East, Dublin 2 (tel: 01-6713414)

GANDON EDITIONS

Gandon Editions is the leading producer of books on Irish art and architecture. Established in 1983, it was named after the architect James Gandon (1743-1823) as the initial focus was on architecture titles. We now produce 20 art and architecture titles per year, both under the Gandon imprint and on behalf of a wide range of art and architectural institutions in Ireland. We have produced 300 titles to date. Gandon books are available from good bookshops in Ireland and abroad, or direct from Gandon Editions.

PROFILES

In 1996, Gandon Editions launched PROFILES – a series of medium-format books on contemporary Irish artists. In 1997, we launched ARCHITECTURE PROFILES – a companion series on contemporary Irish architects. Both series are edited and designed by John O'Regan.

Each volume in the PROFILES series carries at least two major texts – a critical essay and an interview with the artist or architect – and is comprehensively illustrated in colour. In response to demand from readers, we have expanded the pagination and colour content of both series, reinforcing the two PROFILES series as the key reference series on contemporary Irish artists and architects.

Am... Coogan

ART PROFILES

Profile 1 – PAULINE FLYNN
essays by Paul M O'Reilly and Gus Gibney
ISBN 0946641 722 Gandon Editions, 1996
48 pages 22 illus (incl 19 col) €10 pb

Profile 2 – SEÁN McSWEENEY
essay by Brian Fallon; interview by Aidan Dunne
ISBN 0946641 862 Gandon, Spring 2005
(2nd revised and expanded ed; 1st ed, 1996)
60 pages col illus €10 pb

Profile 3 – EILÍS O'CONNELL
essay by Caoimhín Mac Giolla Léith; interview by Medb Ruane
ISBN 0946641 870 Gandon Editions, 1997
48 pages 35 illus (incl 27 col) €10 pb

Profile 4 – SIOBÁN PIERCY
essay by Aidan Dunne; interview by Vera Ryan
ISBN 0946641 900 Gandon Editions, 1997
48 pages 38 illus (incl 32 col) €10 pb

Profile 5 – MARY LOHAN
essay by Noel Sheridan; intro and interview by Aidan Dunne
ISBN 0946641 889 Gandon Editions, 1998
48 pages 22 illus (incl 21 col) €10 pb

Profile 6 – ALICE MAHER
essay and interview by Medb Ruane
ISBN 0946641 935 Gandon Editions, 1998
48 pages 29 illus (incl 23 col) €10 pb

Profile 7 – CHARLES HARPER
essay by Gerry Walker; interview by Aidan Dunne; afterword by Bob Baker

ISBN 0946846 111 Gandon Editions, 1998
48 pages 24 illus (incl 19 col) €10 pb

Profile 8 – MAUD COTTER
essay and interview by Luke Clancy
ISBN 0946846 073 Gandon Editions, 1998
48 pages 30 illus (incl 24 col) €10 pb

Profile 9 – MICHEAL FARRELL
essay by Aidan Dunne; intro and interview by Gerry Walker
ISBN 0946846 138 Gandon Editions, 1998
48 pages 33 illus (incl 25 col) €10 pb

Profile 10 – BARRIE COOKE
intro by Seamus Heaney; essay by Aidan Dunne; interview by Niall MacMonagle
ISBN 0946846 170 Gandon Editions, 1998
48 pages 29 illus (incl 25 col) €10 pb

Profile 11 – VIVIENNE ROCHE
essay by Ciarán Benson; intro and interview by Aidan Dunne
ISBN 0946846 235 Gandon Editions, 1999
48 pages 39 illus (incl 30 col) €10 pb

Profile 12 – JAMES SCANLON
essay by Aidan Dunne; interview by Shane O'Toole; afterword by Mark Patrick Hederman
ISBN 0946641 579 Gandon Editions, 2000
48 pages 51 illus (incl 37 col) €10 pb

Profile 13 – TONY O'MALLEY
essay by Peter Murray; intros by Jay Gates, Jean Kennedy Smith
ISBN 0946846 456 Gandon Editions, 2000
48 pages 30 illus (incl 26 col) €10 pb

Profile 14 – ANDREW KEARNEY
essay by Simon Ofield; interview by Aoife Mac Namara; intro by Mike Fitzpatrick
ISBN 0946846 74X Gandon Editions, 2001
60 pages 83 illus (incl 69 col) €10 pb

Profile 15 – BERNADETTE KIELY
essay by Aidan Dunne; interview by Jo Allen; afterword by Ciarán Benson
ISBN 0946846 804 Gandon Editions, 2002
60 pages 41 illus (incl 35 col) €10 pb

Profile 16 – ANNE MADDEN
essay and interview by Aidan Dunne
ISBN 0946846 863 Gandon Editions, 2002
60 pages 42 illus (incl 37 col) €10 pb

Profile 17 – ANDREW FOLAN
essay by Paul O'Brien; intro and interview by
Patrick T Murphy
ISBN 0946641 919 Gandon Editions, 2002
60 pages 57 illus (incl 46 col) €10 pb

Profile 18 – JOHN SHINNORS
essay by Brian Fallon; intro and interview by
Aidan Dunne
ISBN 0946846 782 Gandon Editions, 2002
60 pages 51 illus (incl 49 col) €10 pb

Profile 19 – JACK DONOVAN
essays by Gerry Dukes, Aidan Dunne, John
Shinnors; interview by Mike Fitzpatrick
ISBN 0946846 200 Gandon Editions, 2004
84 pages 90 illus (incl 71 col) €15 pb
*(also available in hb as Jack Donovan – Paintings
1959-2004, ISBN 09544291 33, €25 hb)*

Profile 20 – TOM FITZGERALD
essays by Suzanne O'Shea, Seán Ó Laoire;
interview by Jim Savage
ISBN 0946846 618 Gandon Editions, 2004
84 pages 92 illus (incl 75 col) €15 pb
*(also available in hb as Tom Fitzgerald – The
Ministry of Dust, ISBN 09544291 41, €25 hb)*

Profile 21 – AMANDA COOGAN
essays by Caoimhín Mac Giolla Léith, Apinan
Poshyananda; interview by Mike Fitzpatrick;
intro by Marina Abramovic
ISBN 0948037 172 Gandon Editions, 2005
72 pages 92 illus (incl 85 col) €15 pb
*(also available in hb as Amanda Coogan – A brick
in the handbag, ISBN 09544291 68, €25 hb)*

Profile 22 – DONALD TESKEY
essays by Frank McGuinness, Aidan Dunne;
interview by Mike Fitzpatrick
ISBN 0948037 245 Gandon Editions, 2005
108 pages 119 illus (incl 100 col) €20 pb
*(also available in hb as Donald Teskey – Tidal
Narratives, ISBN 09544291 84, €30 hb)*

Profile 23 – DAPHNE WRIGHT
essays by Penelope Curtis, Isabel Nolan;
interview by Simon Morrrissey
ISBN 0948037 261 Gandon Editions, 2006
84 pages 96 illus (incl 63 col) €15 pb

Profile 24 – PAUL DORAN
essays by Robbie O'Halloran, Sally O'Reilly;
interview by Mark Swords
ISBN 0948037 30X Gandon Editions, 2006
84 pages 63 col illus €15 pb
*(also available in hb as Paul Doran – Man in a
shed, ISBN 0948037 334, €25 hb)*

ARCHITECTURE PROFILES

Profile 1 – O'DONNELL + TUOMEY
interview by Kester Rattenbury; texts by Hugh
Campbell, Kevin Kieran, Robert Maxwell, Wilfried
Wang, Williams & Tsien
ISBN 0946641 986 Gandon Editions, 1997
48 pages 64 illus (incl 27 col) €10 pb

Profile 2 – McGARRY NíÉANAIGH
essay by Raymund Ryan; interview by
Dermot Boyd
ISBN 0946641 994 Gandon Editions, 1997
48 pages 56 illus (incl 26 col) €10 pb

Profile 3 – GRAFTON ARCHITECTS
essays by Hugh Campbell, Kenneth Frampton,
Elizabeth Hatz; interview by Raymund Ryan
ISBN 0946846 057 Gandon Editions, 1999
60 pages 131 illus (incl 86 col) €10 pb

Profile 4 – SHAY CLEARY
essay by Raymund Ryan; interview by Simon
Walker; afterword by Edward Jones
ISBN 0946846 898 Gandon Editions, 2002
132 pages full-colour 320 illus €20 pb

titles in preparation
Louis LE BROCQUY
Michael CULLEN
Camille SOUTER

ORDER FORM

These books can be ordered from any good
bookshop or direct from Gandon Editions
(same-day dispatch; postage free in Ireland;
elsewhere at cost). Please indicate quantities
required alongside volume numbers below:

ART PROFILES
____°1 ____°2 ____°3 ____°4 ____°5
____°6 ____°7 ____°8 ____°9 ____°10
____°11 ____°12 ____°13 ____°14 ____°15
____°16 ____°17 ____°18 ____°19 ____°20
____°21 ____°22 ____°23 ____°24
____ forthcoming: _____
____ _____

ART PROFILES clothbound editions
____°19 ____°20 ____°21 ____°22 ____°24

ARCHITECTURE PROFILES
____°1 ____°2 ____°3 ____°4

■ PAYMENT – You can order by phone,
fax, e-mail or post ... and pay by credit card or
by € euro / £ stg / $ US dollar cheque.
❏ cheque enclosed € / £ / $ _____
❏ charge to Laser / Mastercard / Visa a/c

__ __ __ __ __ __ __ __ __ __ __ __ __ __ __ __

expiry date ___ ___ / ___ ___ security code ___ ___ ___

name _____
PRINT NAME & ADDRESS
address _____

TRADE: order # _____ S/R; usual terms apply

GANDON EDITIONS
Oysterhaven, Kinsale, Co Cork, Ireland
T +353 (0)21-4770830 / F 021-4770755
E gandon@eircom.net 3/06